From Eastern Europe:

Graphic design from Eastern Europe, compiled and published by Counter-Print

First published in 2018 © Counter-Print
Reprinted in 2020
ISBN 978-0-9935812-6-7 Designed by Jon Dowling & Céline Leterme
www.counter-print.co.uk

With special thanks to all the contributors.

This book is about graphic design from Eastern Europe, including works from Croatia, Czech Republic, Estonia, Hungary, Poland, Russia and Serbia. It arrives as the third edition of this publication, which previously featured work from Japan and Scandinavia.

The new selection pays particular attention to corporate identity projects from recent years and includes many progressive projects which highlight the changing visual and artistic tastes of this geographic area.

In introducing this work, it is important to outline how we are defining 'Eastern Europe' in this case. There is no real consensus on the precise area it covers, partly because the term has a wide range of geopolitical, geographical, cultural and socio-economic connotations. However, my definition – a child of the 80's, sitting at my desk somewhere in the South of England – is a product of the Cold War and is, more or less, synonymous with the terms 'Eastern Bloc' and 'Warsaw Pact'. A similar definition includes the formerly communist European states outside the Soviet Union as 'Eastern Europe'. As such, it might seem outdated but is a useful construct for this book, which aims to bring together the work of geographic areas to celebrate their cultural value and their influence on design globally.

The history of this region, its upheaval during WW1 and the Russian revolution of 1917, is of huge importance when tackling the artistic output of countries within it. The revolution was a time of huge change, leading to the dismantling of the Tsarist regime. As the Tsar was overthrown, Russia was torn into civil war and the Soviet Union was formed. Many countries were fractured and Eastern Europe and its societies reshaped. This turbulence was accompanied by an explosion of art in Russia. By turn, the art from this period had an international influence on twentieth century graphic design elsewhere in Europe and beyond.

Russian artists, fired by revolution and the promise of a brighter future, absorbed the ideas of Cubism and Futurism and moved them on to create new innovations. Renowned artists including Malevich, Kandinsky, Chagall and Rodchenko were among those to bear witness to the 1917 revolution. Malevich created Suprematism, introducing a formal combination of geometry, combined with a limited colour palette, which went on to strongly influence Constructivism and later Modernism, thus impacting how we approach art and design today in the 21st century. →

Constructivists like Rodchenko, reacting against Tsarist symbolism, forsook painting for graphic design and photojournalism and developed a style that focused on a stripped-down palette of primary colours, the use of photo-montage and a preference for angles and straight lines. The shapes and ideas composing space that developed in painting and sculpture were quickly applied to problems of design.

However, by the end of 1932, Stalin's brutal suppression had drawn the curtain down on creative freedom. The Soviet Union's party ideologies quickly came to find the modern visual language suspicious – abstract approaches were mysterious, with hidden meanings that encouraged interpretation. These avant-garde methods returned in the later 20th century, but not before they were superseded and pushed out of the public sphere by Socialist Realism. Soviet design suffered from such censorship of creativity.

In a totalitarian political system where aggressive propaganda played a central role and the economy was centrally planned, there was no need for corporate designs that would compete with one another, or even offer something for sale. Clients were state controlled institutions and industry, while university courses were focusing on technique, rather than allowing students to design with creative freedom. That said, there are many celebrated designers from this era; the logo design of Stefan Kanchev from Bulgaria, the celebrated Polish and Hungarian poster art, Czechoslovakian match box design and Russian safety at work posters have all come to be admired globally.

With the fall of the Iron Curtain in 1989, the political landscape of the Eastern Bloc, and indeed the world, changed. A new market for design was brought into being and Eastern European designers, as shown in this book, came to flourish on the global design scene, reclaiming the dynamic geometry, bold typography and minimalist use of colour that feels as current today as it did at the time of revolution.

If I ask myself whether Eastern Europe has a specific design style? I think there is, it's just that we have all, perhaps unwittingly, absorbed it and it has become part of a global trend now. Perhaps it is time to remember where it came from – a monumental period in human history.

Jon Dowling
Counter-Print

Anna Kulachek

kulachek.com

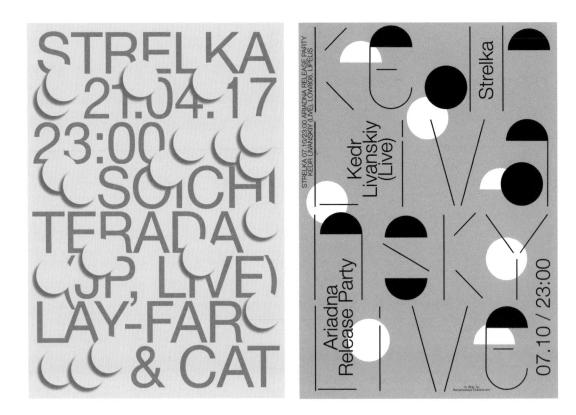

Soichi Terada
2017

Kedr Livanskiy
2017

→
Doug Hream
2016

Posters for Strelka Bar

STRELKA

17.09
23:00

DOUG
DREAM
BLUNT
(US, LIVE)

STRELKA
ALL STARS BAND:
JENYA GORBUNOV
(GLINTSHAKE)
DIMA MIDBORN
(ON-THE-GO)
SASHA LIPSKY
(POMPEYA)
GRISHA DOBRYNIN
(ON-THE-GO)
KATE
SHILONOSOVA (NV)
ANDREY BESSONOV
VIKTOR GLAZUNOV

SPUTNIK
SIMPLE SYMMETRY

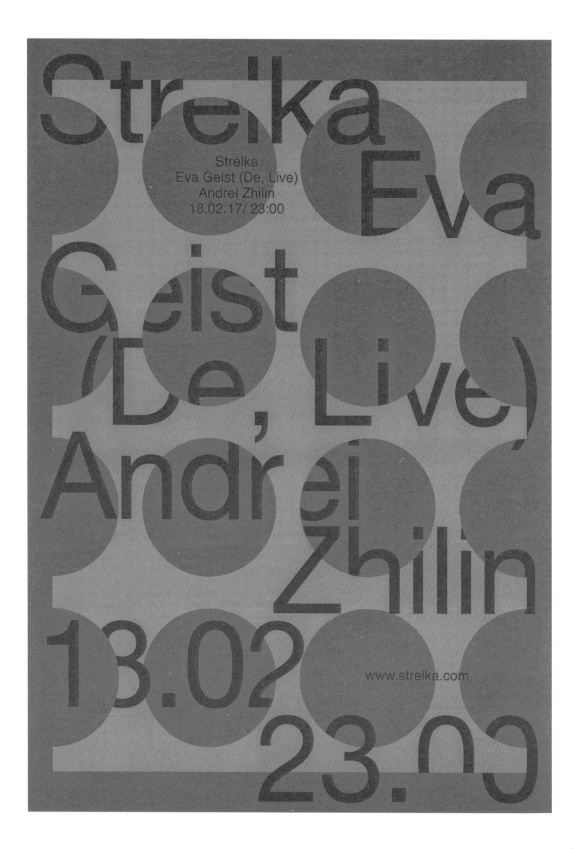

Strelka
Eva Geist (De, Live)
Andrei Zhilin
18.02.17/ 23:00

Strelka Eva Geist (De, Live) Andrei Zhilin 13.02 23.00

www.strelka.com

←

Eva Geist

2016

New Year 2018

2018

UEFA 2016

2016

Posters for Strelka Bar

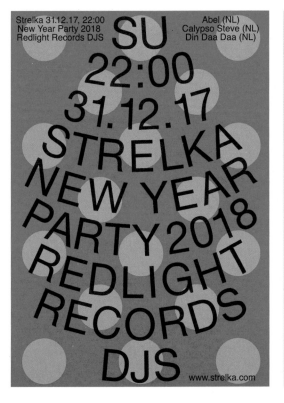

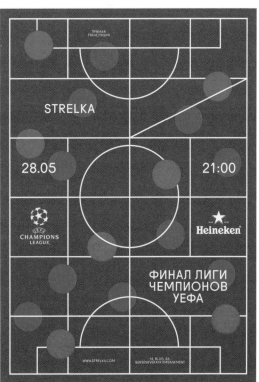

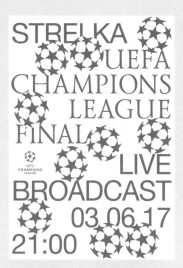

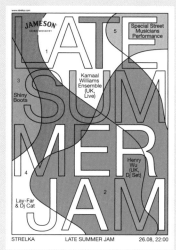

UEFA 2017
2017

Jameson
2017

Austra
2016

Jan Schulte
2018

DJ Lag
2018

African Acid
2017

→

Sacha Mambo
2018

Posters for Strelka Bar

STRELKA
04.03/23:00
THAT'S
A STEAL
PARTY
JULIAN
HORN (AT)
LIPELIS
SPUTNIK
SHINY
BOOTS

Julian Horn (AT)

Strelka 04.03/ 23:00
That's A Steal Party

Lipelis, Sputnik,
Shiny Boots

www.strelka.com

←

Julian Horn
2016

HYSTERIC
2017

Dorogoy Sereja
2018

Posters for Strelka Bar

FUTURE OF THE WORD

FUTURE OF THE WORD

FUTURE OF THE WORD

FUTURE OF THE WORD AFTERPARTY
PETER COLLINGRIDGE (UK), PHILIPP PETRENKO
04.06.2016 / 22:00

WWW.STRELKA.COM, WWW.BRITISHCOUNCIL.RU
14, BLDG. 5, BERSENEVSKAYA EMBANKMENT

FUTURE OF THE WORD

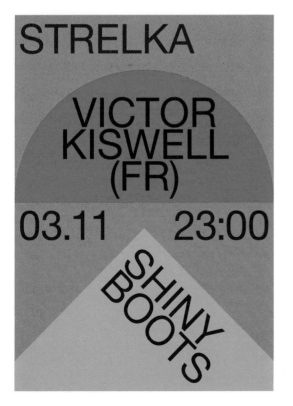

Posters for Strelka Bar

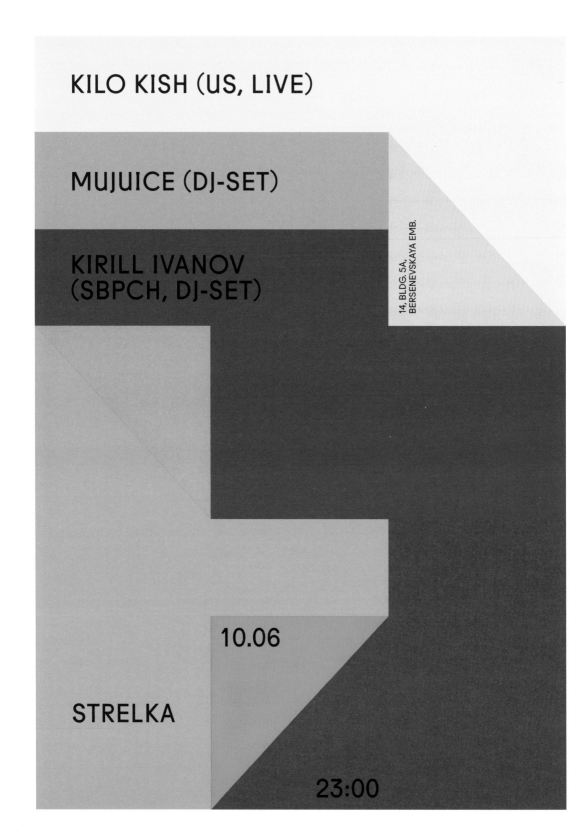

KILO KISH (US, LIVE)

MUJUICE (DJ-SET)

KIRILL IVANOV
(SBPCH, DJ-SET)

14, BLDG. 5A,
BERSENEVSKAYA EMB.

10.06

STRELKA

23:00

The Bakery

madebythebakery.com

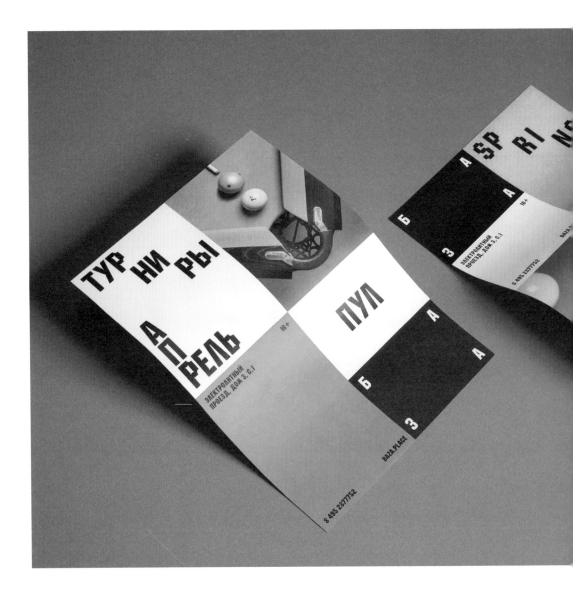

Baza
—
Branding for a restaurant
with billiards
2017

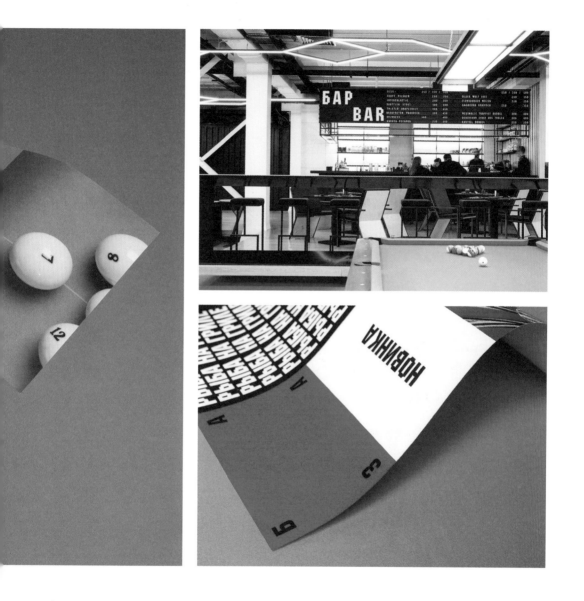

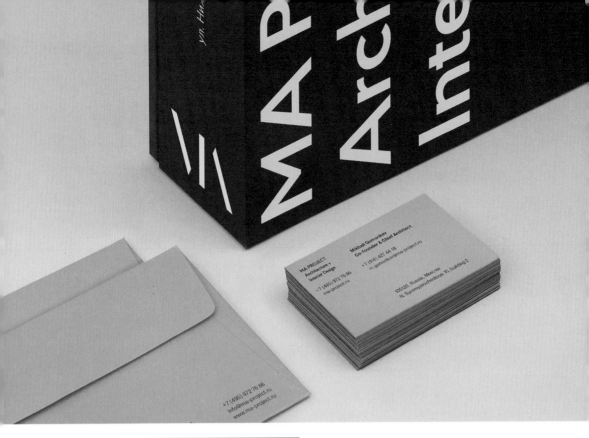

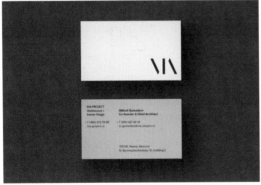

MA Project

Branding for an architecture
& interior design company
2016

The Bakery

NGRS
––––
Branding for a recruitment company
2016

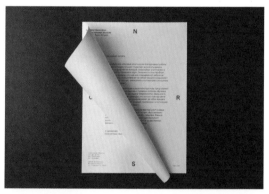

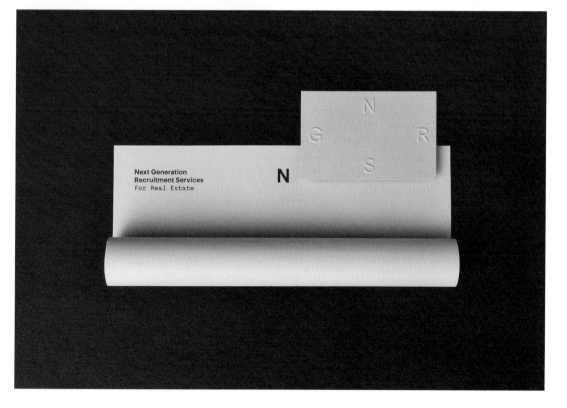

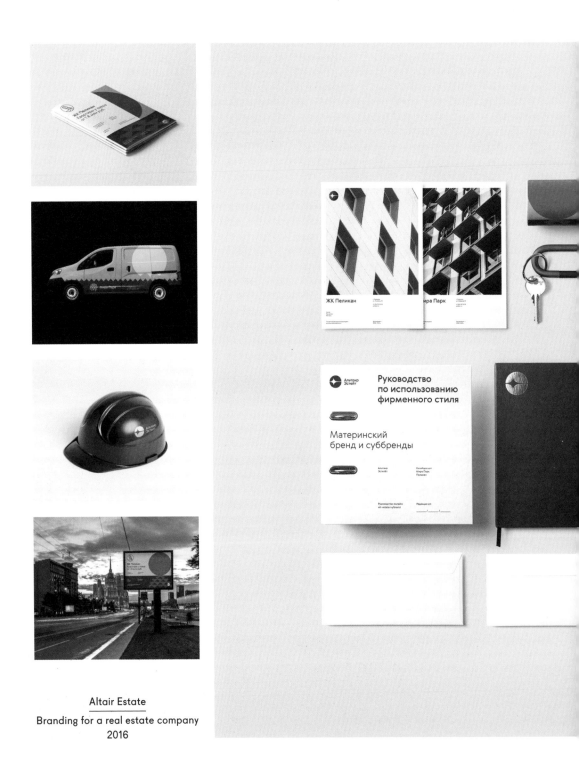

Altair Estate
Branding for a real estate company
2016

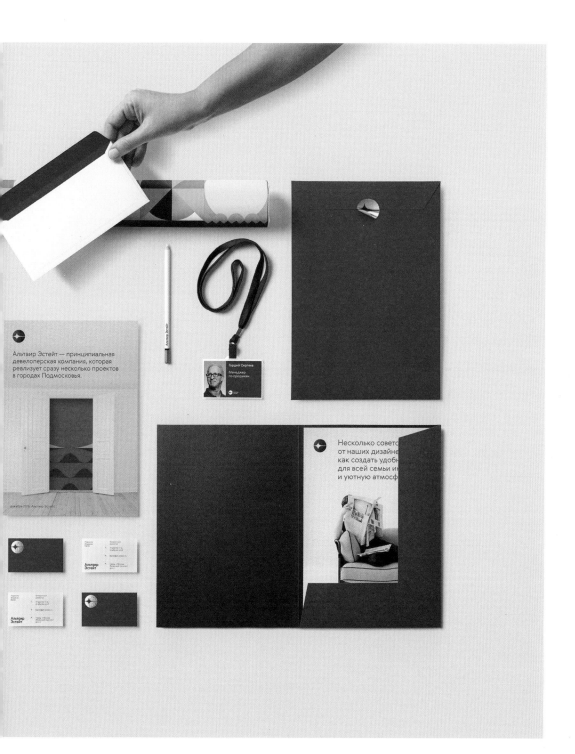

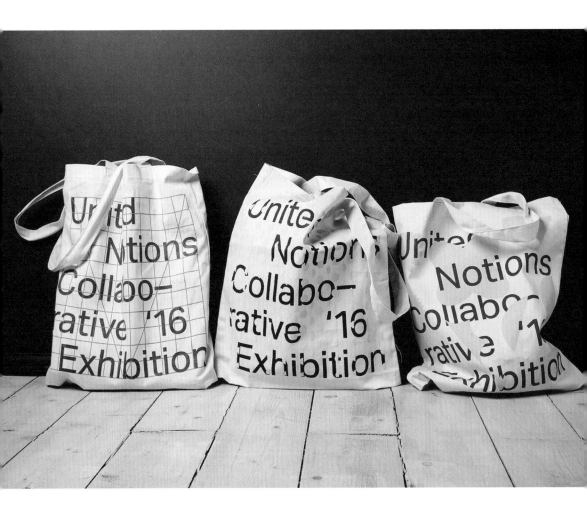

United Notions

Identity for an initiative offering
international exhibitions & education
2016

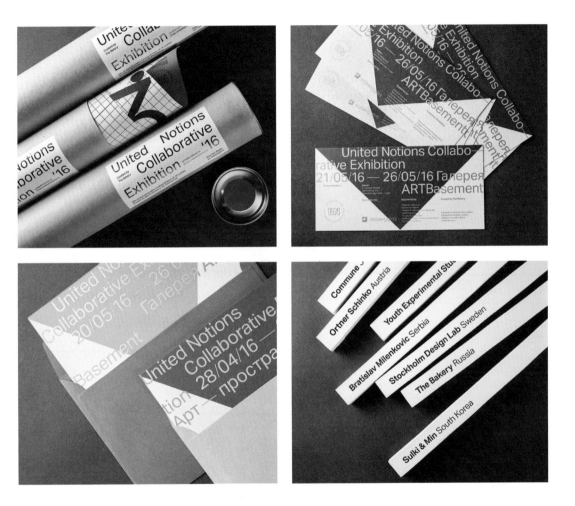

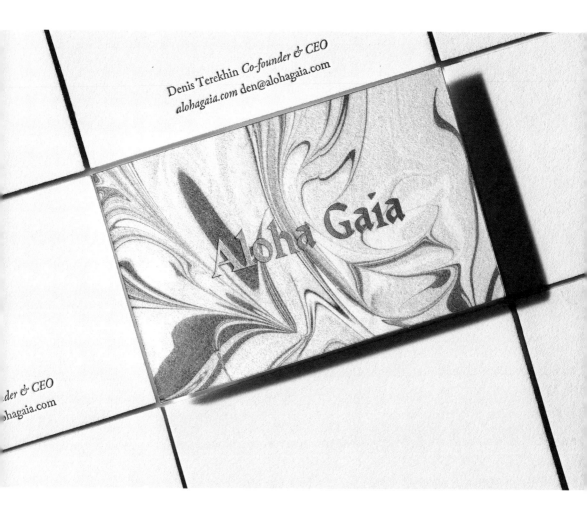

Aloha Gaia

Branding & stationery design for
a jewellery company
2013

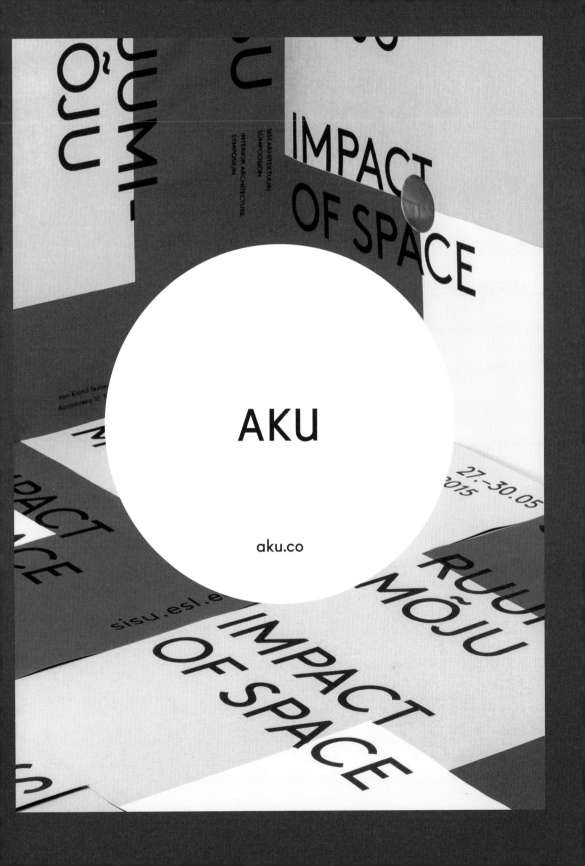

IMPACT
OF SPACE

SISEARHITEKTUURI
SÜMPOOSION
INTERIOR ARCHITECTURE
SYMPOSIUM

JUMI-
ÕJU

Von Krahli Teater
Rataskaevu 10, T...

27.–30.05
2015

RUU
MÕJU

sisu.esl.e...

IMPACT
OF SPACE

AKU

aku.co

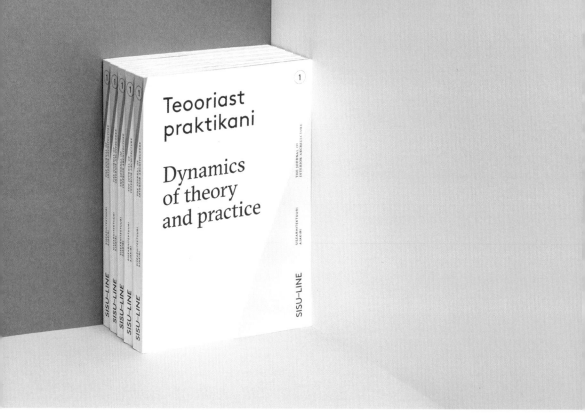

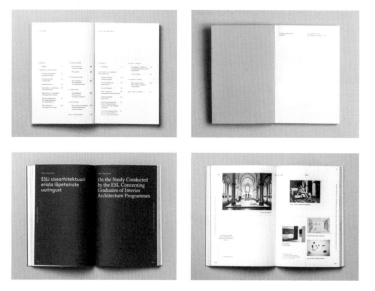

Tallinn Interior Architecture
Symposium
Book design on behalf of the
Estonian Association of Interior
Architects for a design symposium
2015

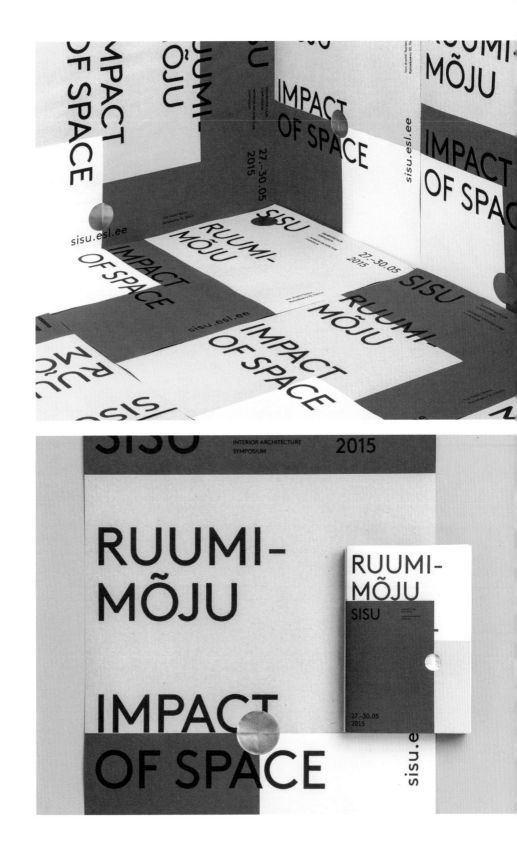

Kaarel Mikkin

Estonian Design Centre

Branding for a non-profit
organisation, connecting designers
with entrepreneurs & the
public sector
2016

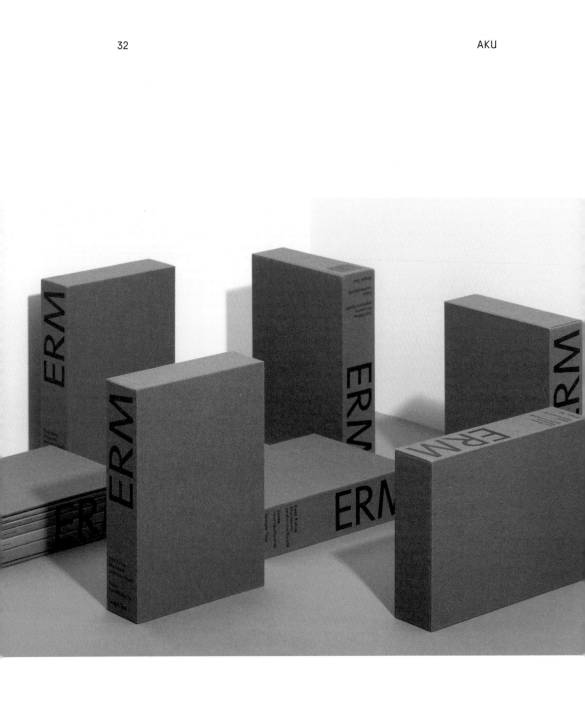

Estonian National Museum

Editorial design for a book on
the architecture of the national
museum of Estonia
2016

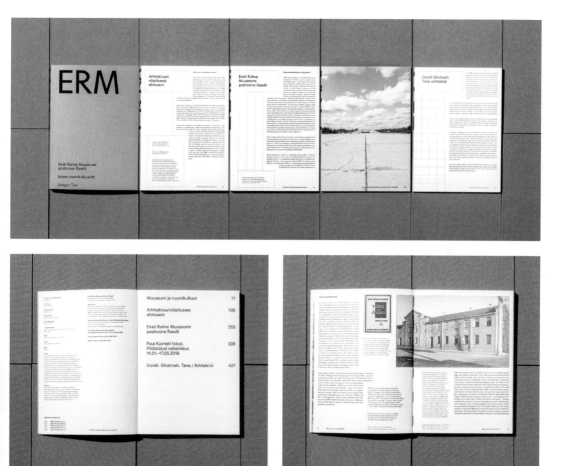

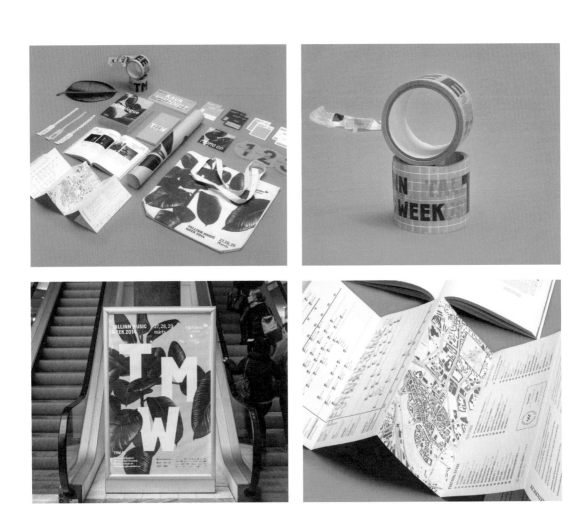

Tallinn Music Week

Identity for a festival & conference
2014

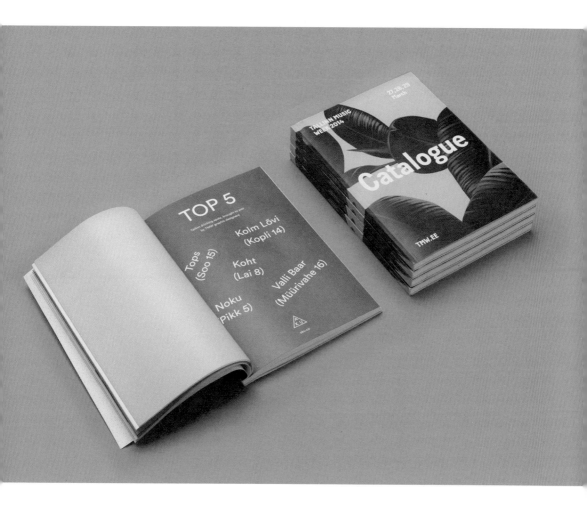

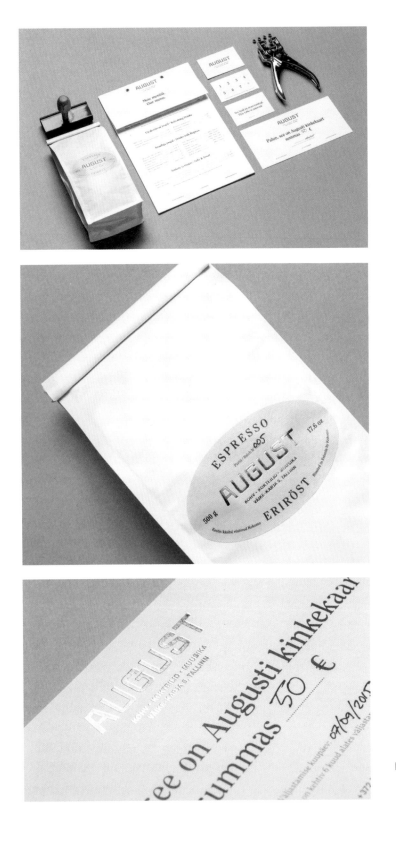

Café August
Branding and signage for a café
& cocktail bar
2015

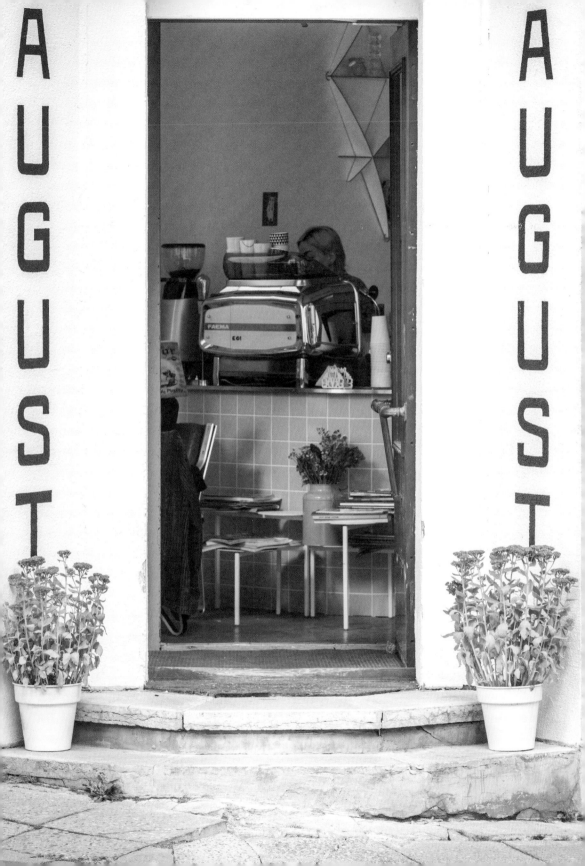

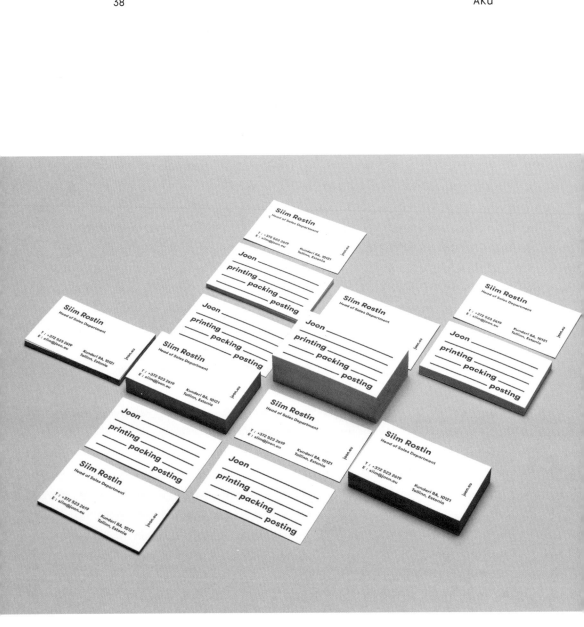

Joon
—
Branding for a printer
2015

Metaklinika

metaklinika.com

Design Papers

carefully created collection

look,
touch and
feel

Design
Papers

carefully
created
collection

Welcome to the World of
Design Papers

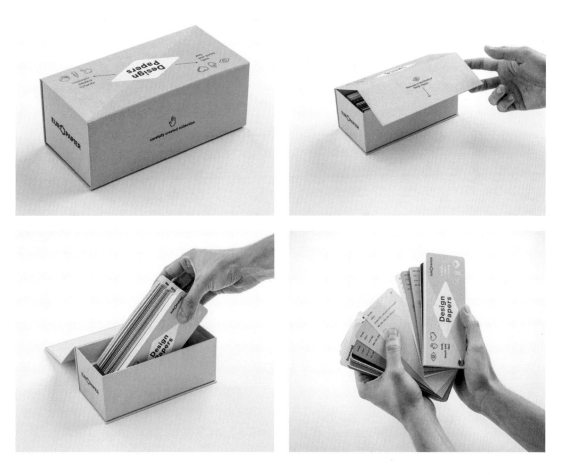

Design Papers
Swatch for Europapier,
a paper merchant
2016

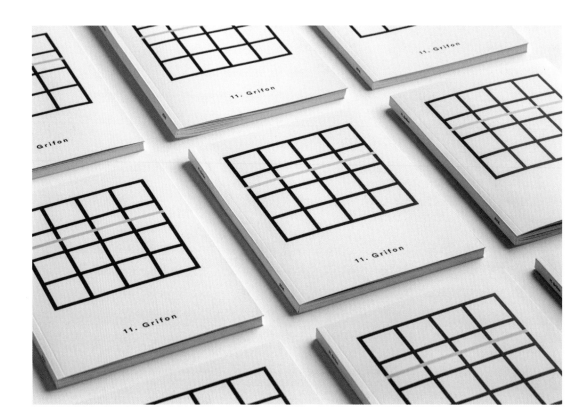

11th Griffin

Identity for Graficki Kolektiv´s
graphic design competition
2016

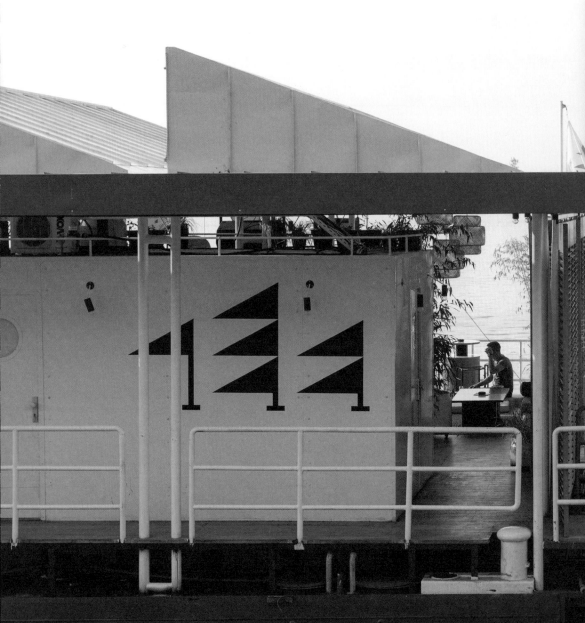

Pristan
Branding for a bar
2016

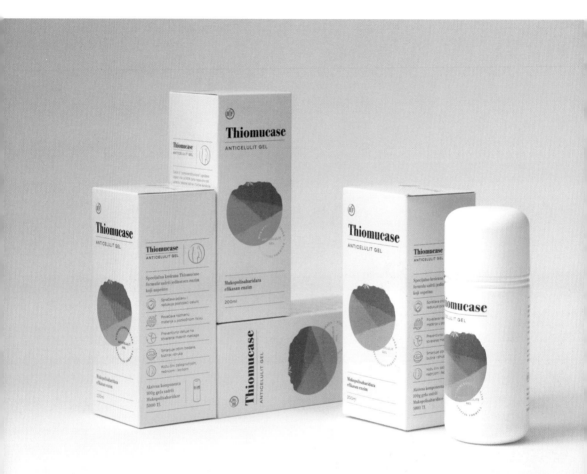

Thiomucase
Packaging design for Hemofarm
STADA Group
2013

Dima Pantyushin

instagram.com/
d.pantyushin

«ЭНТУЗИАСТУ» ЧЕТЫРЕ!
ИЛИ 1460 ДНЕЙ МЫ С ВАМИ
В ПРЯМОМ ЭФИРЕ

20.05.2017

DIMA PANTYUSHIN • MOSCOW • 2017

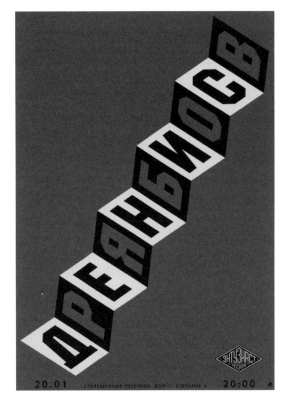

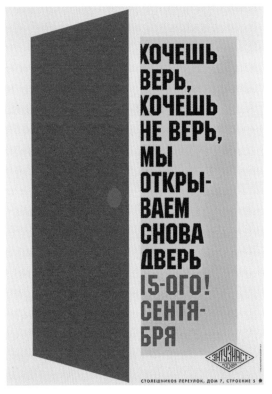

Dima Pantyushin

Denis Ryabov
————
2018

Open Door
————
2017

→
JIR
————
2017

Posters designed for the
moto café Enthusiast

ОТКРЫВАЕМ
КНИЖНЫЙ УГОЛ
ДЕНИСА КРЮКОВА
И ЛЕНЫ ЗАЙКИНОЙ

ЭНТУЗИАСТ МОСКВА

ЖР

«ЖИВЁТ И РАБОТАЕТ»

МУЗЫКА от ARTO SINCE 1900

14.08 СТОЛЕШНИКОВ ПЕРЕУЛОК, ДОМ 7, СТРОЕНИЕ 5 19:00

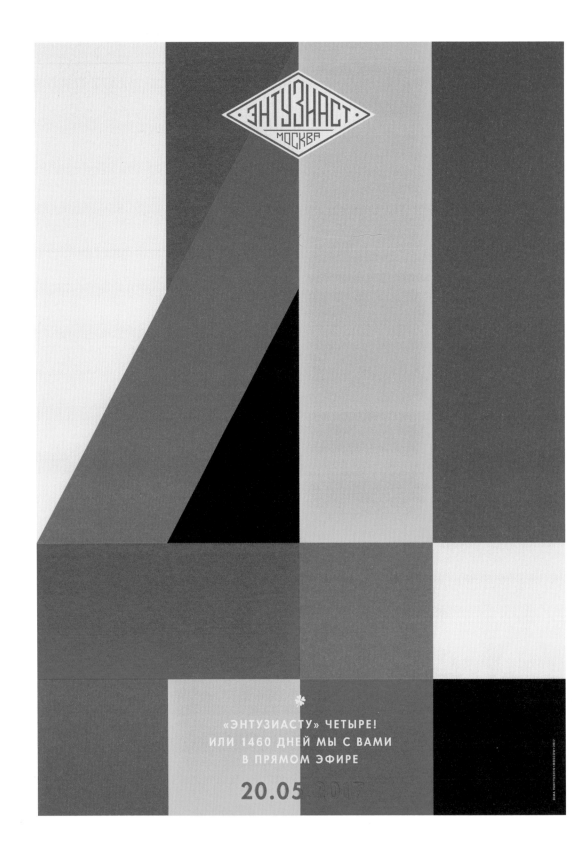

· ЭНТУЗИАСТ ·
МОСКВА

«ЭНТУЗИАСТУ» ЧЕТЫРЕ!
ИЛИ 1460 ДНЕЙ МЫ С ВАМИ
В ПРЯМОМ ЭФИРЕ

20.05.2017

DIMA RAMYTUSHIN•MOSCOW•2017

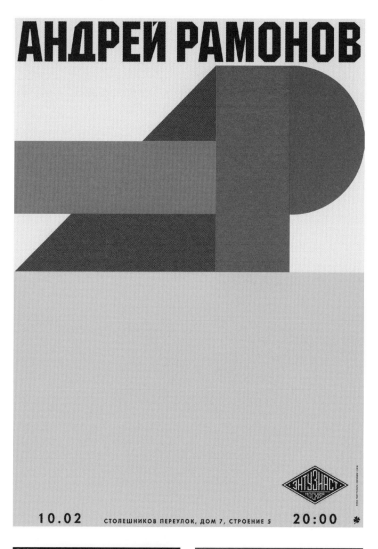

←
Enthusiast 4 Years
2017

Andrey Ramonov
2018

Karmanova Mouse
2018

Plick & Pluch
2017

Posters designed for the
moto café Enthusiast

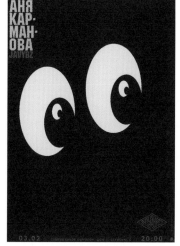

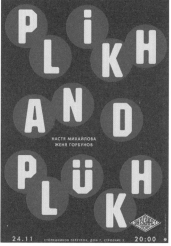

→
La Boule 5 years
2015

→
La Boule Competition
2015

Posters designed for petanque
café La Boule

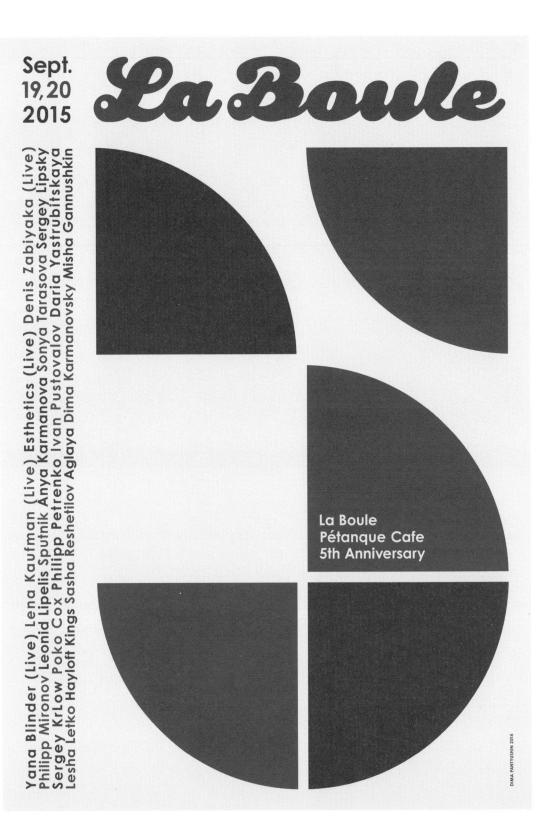

Sept.
19,20
2015

La Boule

Yana Blinder (Live) Lena Kaufman (Live) Esthetics (Live) Denis Zabiyaka (Live) Philipp Mironov Leonid Lipelis Sputnik Anya Karmanova Sonya Tarasova Sergey Lipsky Sergey KrLow Poko Cox Philipp Petrenko Ivan Pustovalov Daria Yastrubitskaya Lesha Letko Hayloft Kings Sasha Reshetilov Aglaya Dima Karmanovsky Misha Gannushkin

La Boule
Pétanque Cafe
5th Anniversary

DIMA PANTYUSHIN 2015

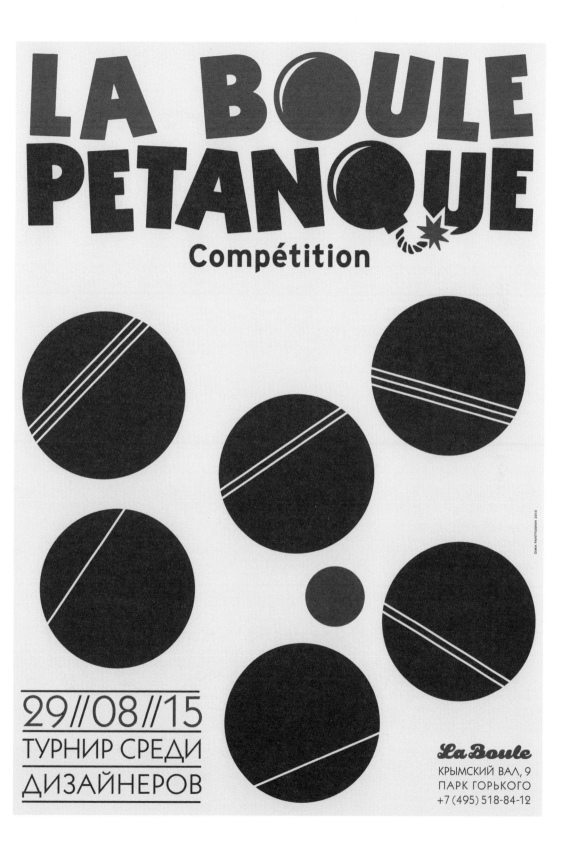

FOREVER • FOREVER • FOREVER • FOREVER • FOREVER • FOREVER • FOREVER

8 Year
Anniversary
of S-11

The
Saint Petersburg
Disco Spin Club
(Live)

Djs
Timofey Smirnov
Sergey Golikov
Kirill Sergeev
Sergey Sergeev
Igor Kompaniets
Tanya Larkin
Sasha Rozet
Dima Grimm
..and more

June,11
Pokrovka, 6
23:00

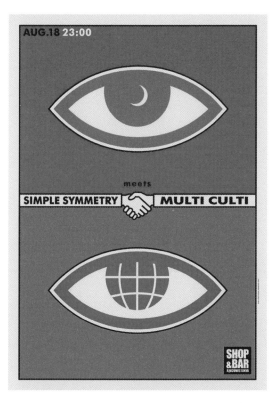

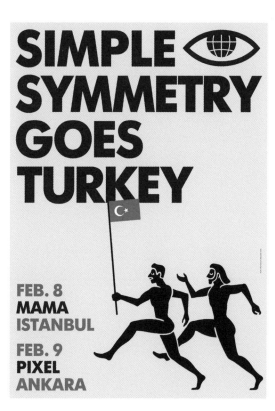

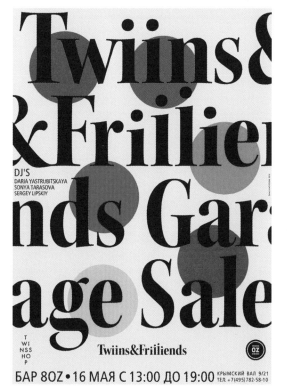

←
S-11 8 Years

Poster for a creative association
2015

Simple Symmetry Meets Multi Culti

Poster for Denis Simachev
Shop & Bar
2015

Simple Symmetry Goes Turkey

Poster for an electronic duo
2017

Twiins Shop and Friends

Poster for a clothing store
2017

→
Konstruktor

Poster for a children's flea market
2015

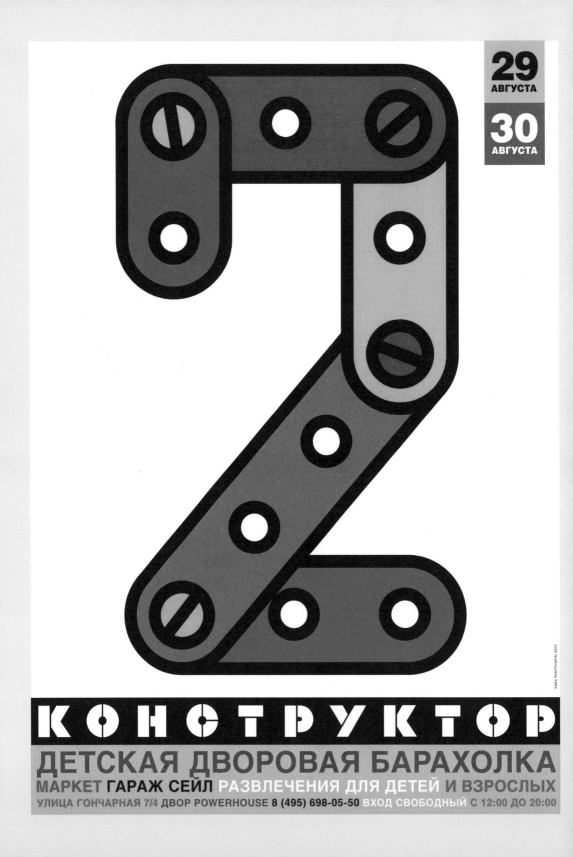

DIMA FANTYUSHIN 2015

Submachine

submachine.co

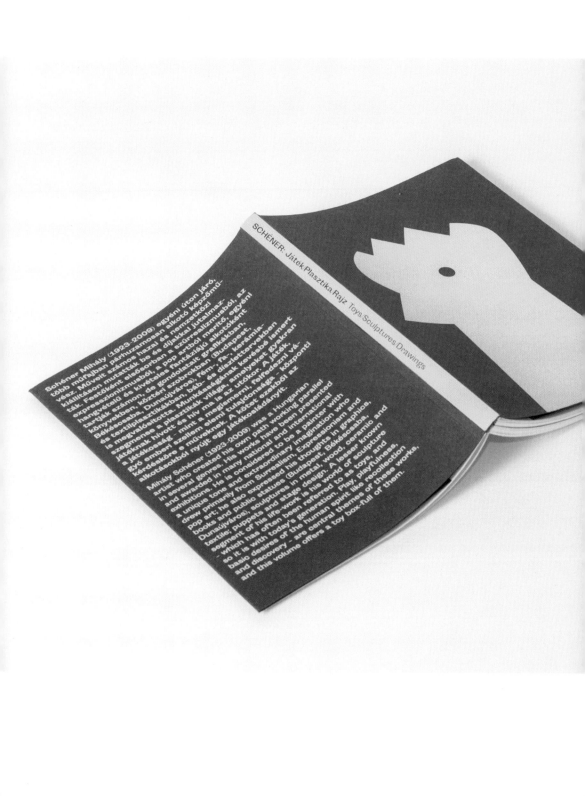

SCHÉNER: Játek Plasztika Rajz Toys Sculptures Drawings

Schéner Mihály (1923-2009) egyéni úton járó, több műfajban párhuzamosan alkotó képzőművész. Művelt számos hazai és nemzetközi kiállításon mutatták be és díjakkal jutalmazták. Festőként elsősorban a pop artból merítő expresszionizmusból, a szürrealizmusból mertő-ként hangvételű és kivételes fantáziájú alkotóként tartják számon de gondolatait grafikákban, könyvekben, köztéri szobrokban (Budapest, Békéscsaba, Dunaújváros), fém-, fa- keramia- és textilplasztikákban, bábokban. A díszlettervekben és megvalósította. Munkásságának kevésbé gyakran szegmense a plasztikák világa, amelyeket gyakran a játékoknak hívott, mint a ma is az utókor. A játék Egy emberi szellemi elemi tulajdonsága. A kötet ezekből a játékosság, mint a megismerni, felfedezni vágy-kérdésekre a műveknek nyújt egy játékosládábányit.

Mihály Schéner (1923-2009) was a Hungarian artist who created his own path working parallel in several genres. His works have been presented and awarded in many national and international exhibitions. He is considered to be a painter with a unique tone and extraordinary imagination who drew primarily from Surrealism, Expressionism and pop art; he also expressed his thoughts in graphics, books and public statues in metal, wood, ceramia and Dunaújváros), sculptures in metal, wood, sculpture textile; puppets and stage design. A lesser known segment of his life-work is his world of as toys, which has often been referred to as toys, and so it is with today's generation Play, playfulness, basic desires of the human spirit like recollection and discovery - are central themes of these works, and this volume offers a toy box-full of them.

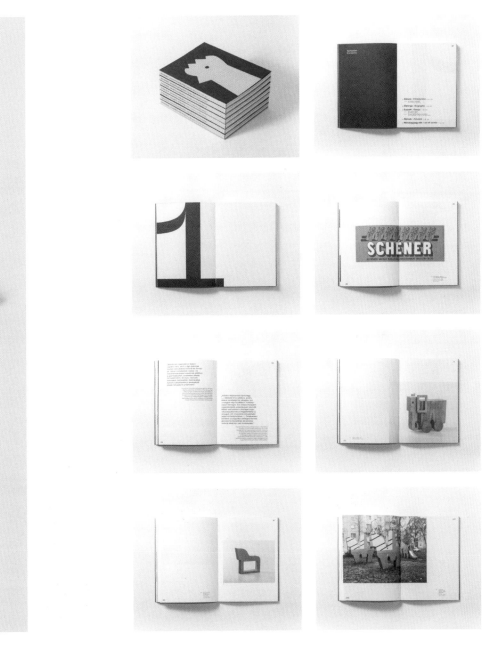

Schéner
Book design for the estate
of Mihály Schéner
2017

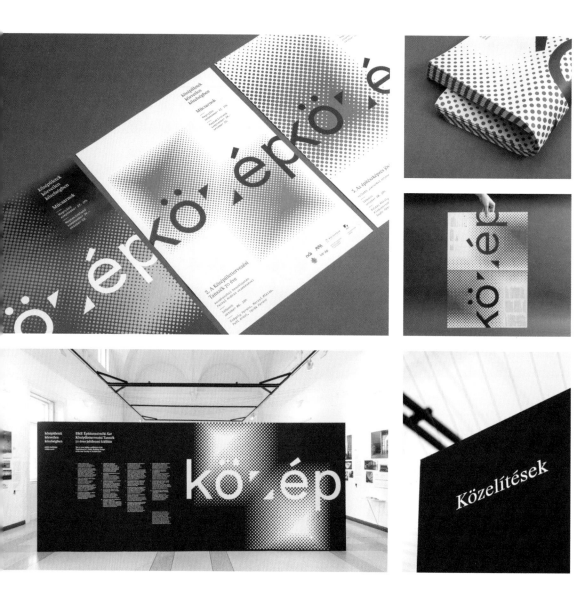

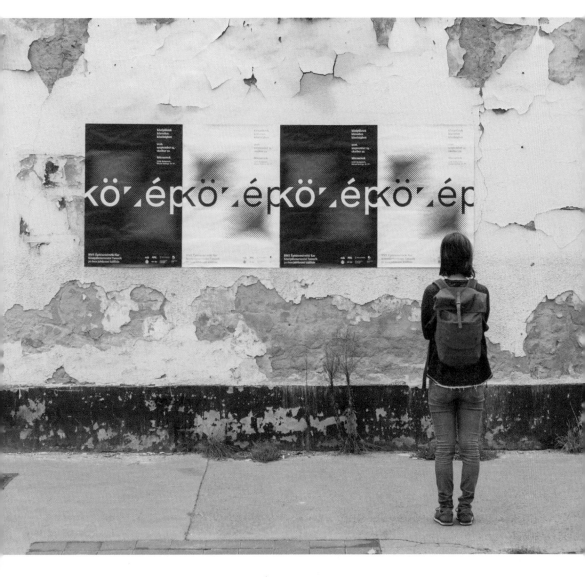

közép
Exhibition design for the Department
of Public Building Design
2016

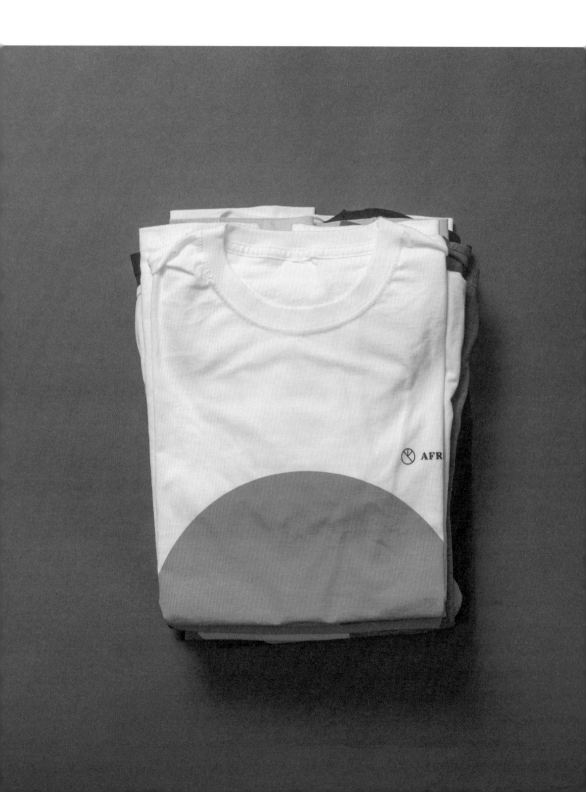

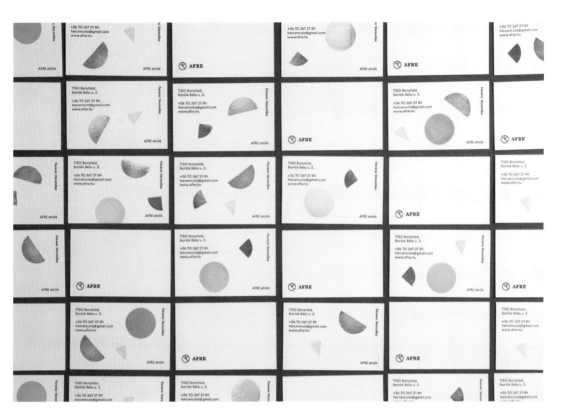

AFRE
—
Branding for an NGO, in collaboration
with Circumstances Creative Co.
2016

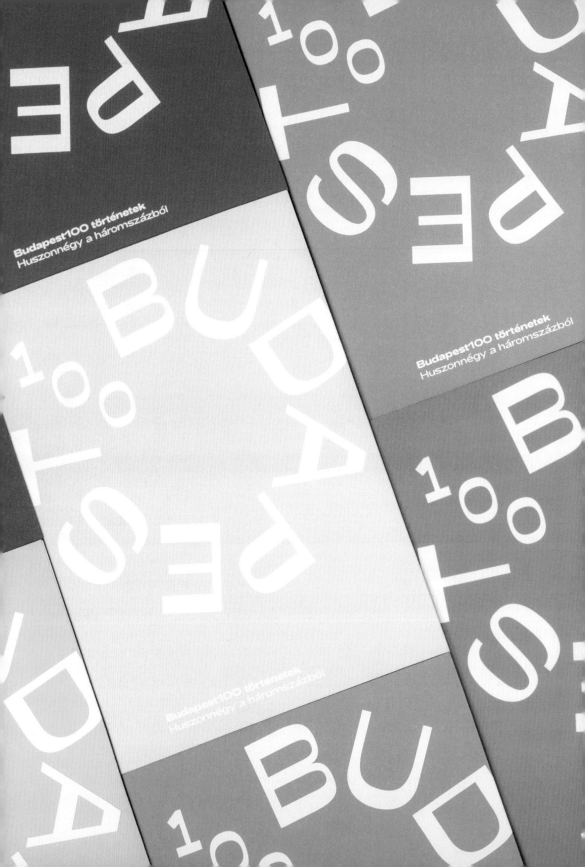

Budapest100 történetek
Huszonnégy a háromszázból

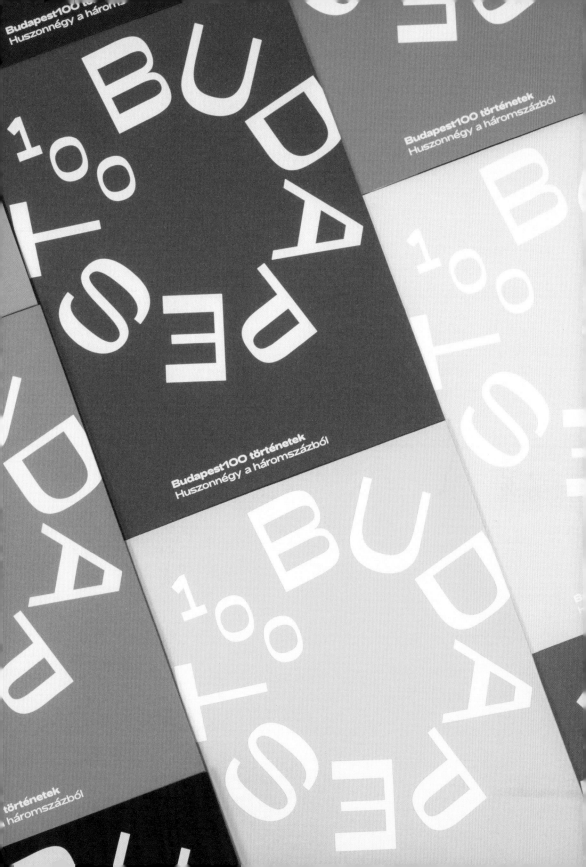

Budapest100 történetek
Huszonnégy a háromszázból

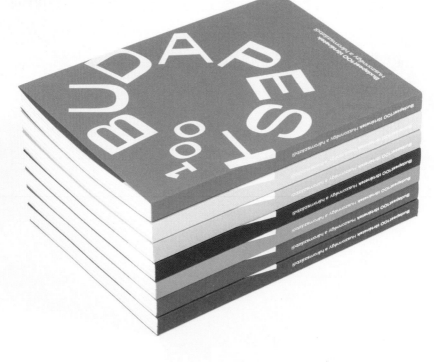

Budapest100 Stories
Book design for KÉK Contemporary
Architecture Centre
2017

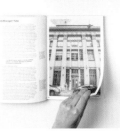

Studio Marvil

marvil.cz

TON Collection

Book design for a bent wood
furniture manufacturer
2017

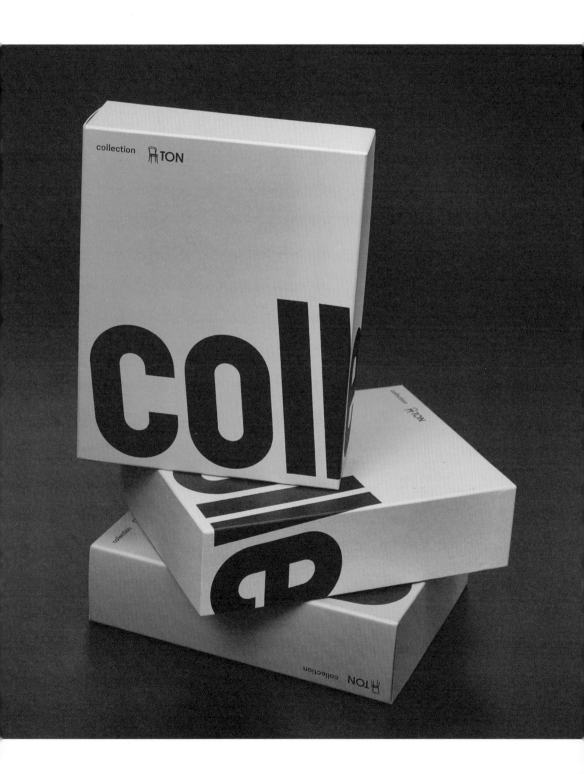

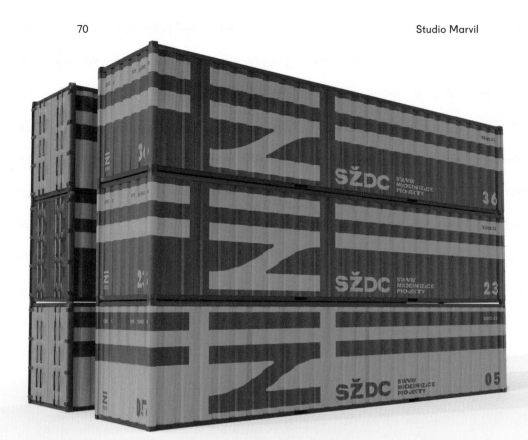

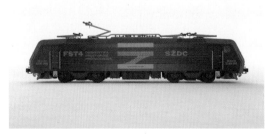

SŽDC

Branding for a railway
administrator
2017

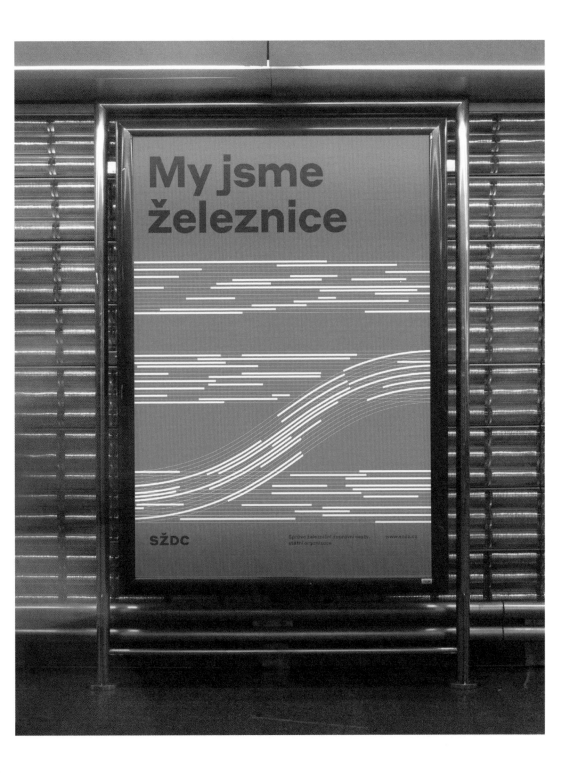

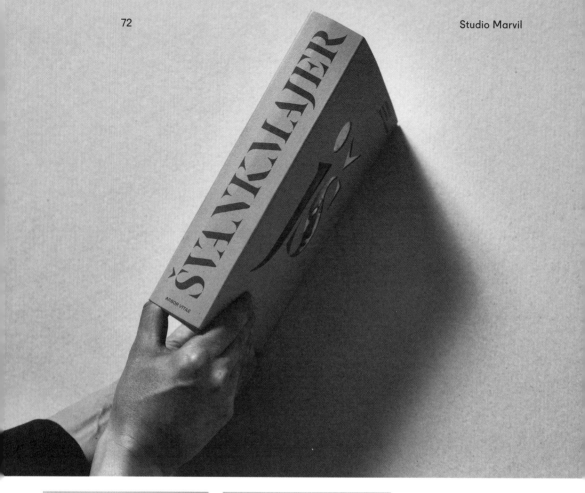

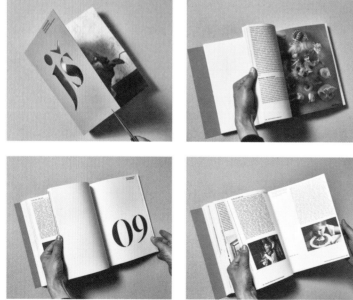

Jan Švankmajer
Book design for Arbor Vitae
Publishing
2013

Classmate

studioclassmate.com

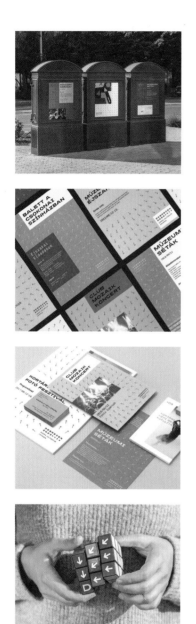

Debrecen 2023

Identity for Debrecen´s year as
European capital of culture
2013

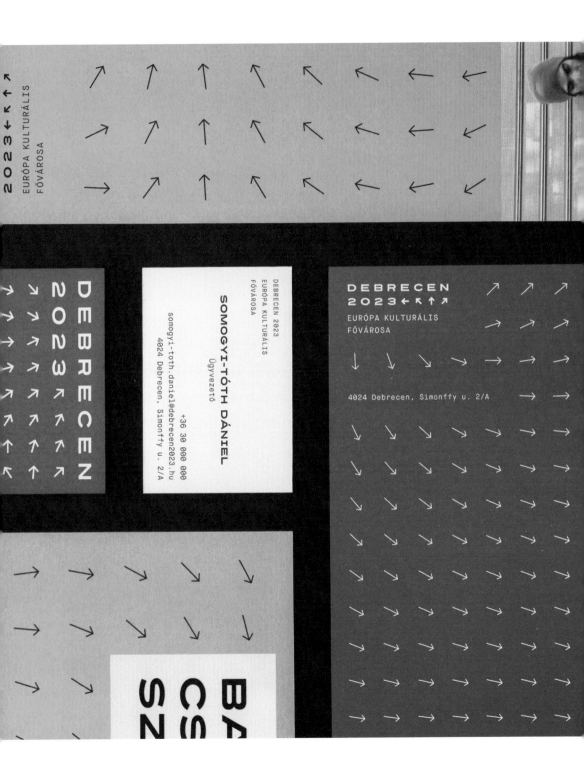

Debrecen 2023
Identity for Debrecen's year as
European capital of culture
2013

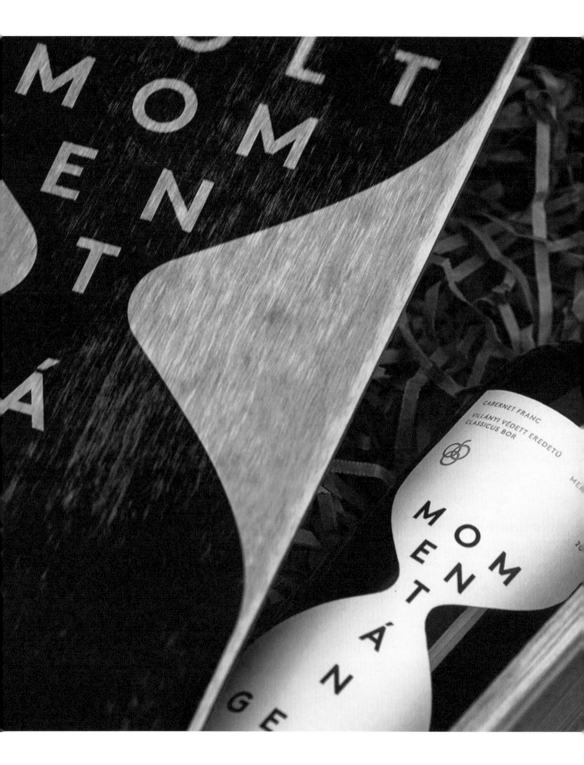

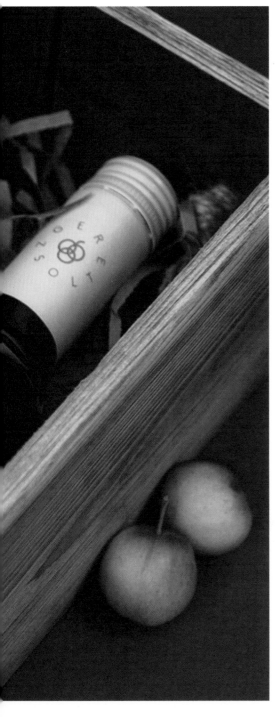

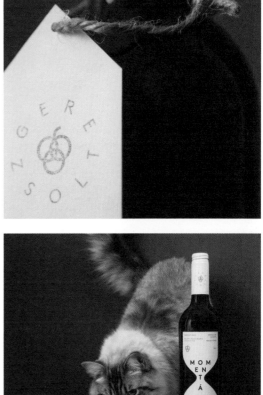

Momentàn
Packaging design for Gere
Zsolt vineyard
2017

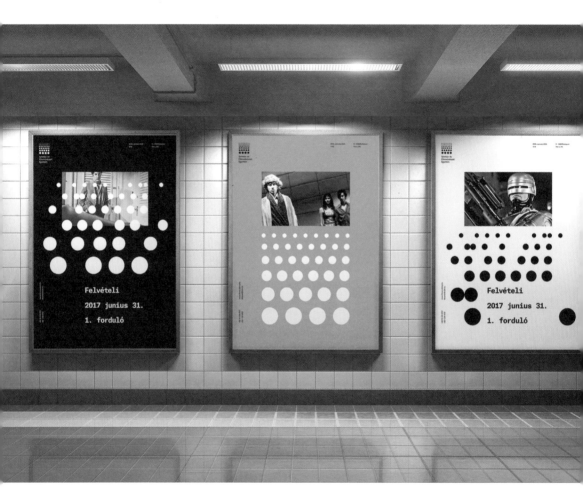

SZFE
—
Branding for the University of
Theatre and Film Arts in Budapest
2016

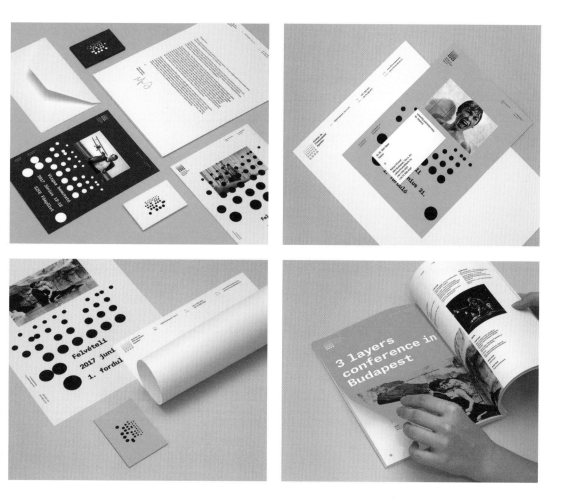

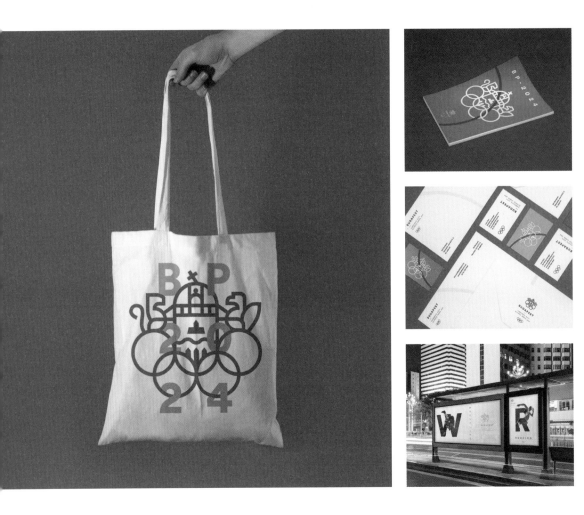

Budapest – Candidate City
Olympic Games
Identity design for Budapest
2016

For Brands

forbrands.pl

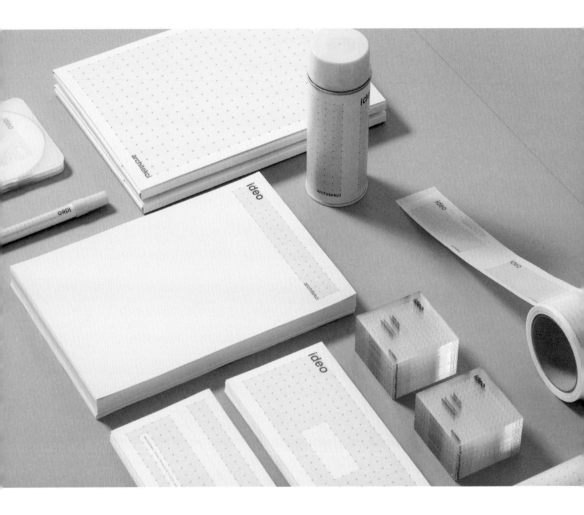

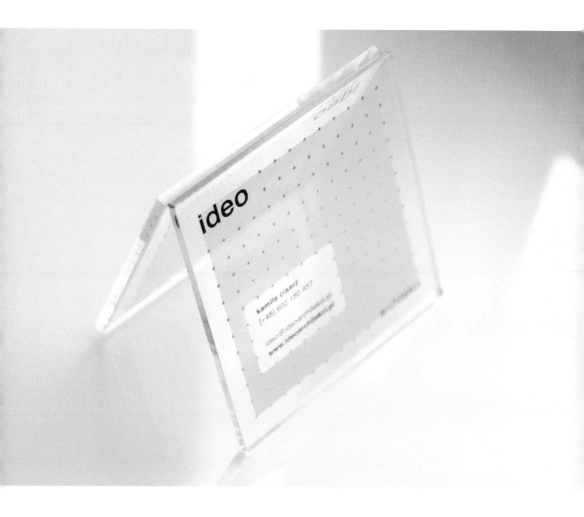

ideo
Branding for an architecture studio
2011

Vesha-Law

Vesha Law
Branding for a law office
2015

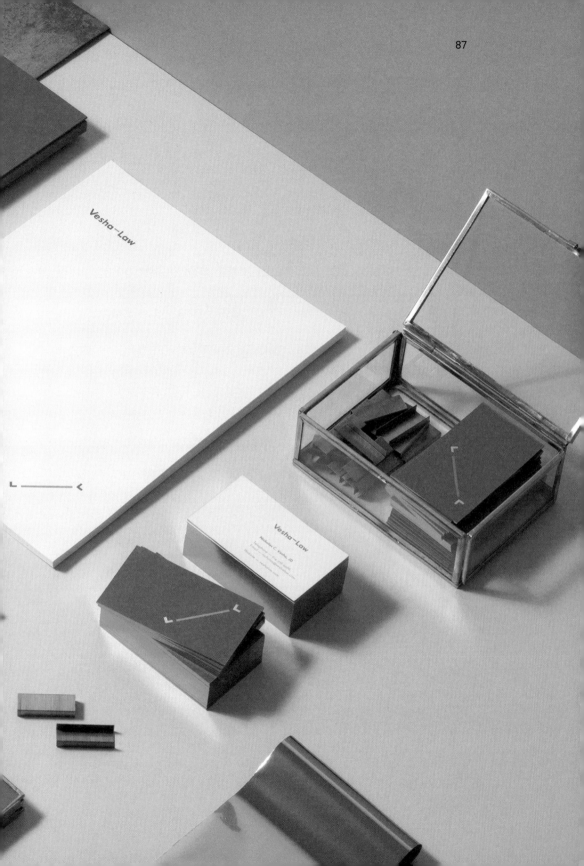

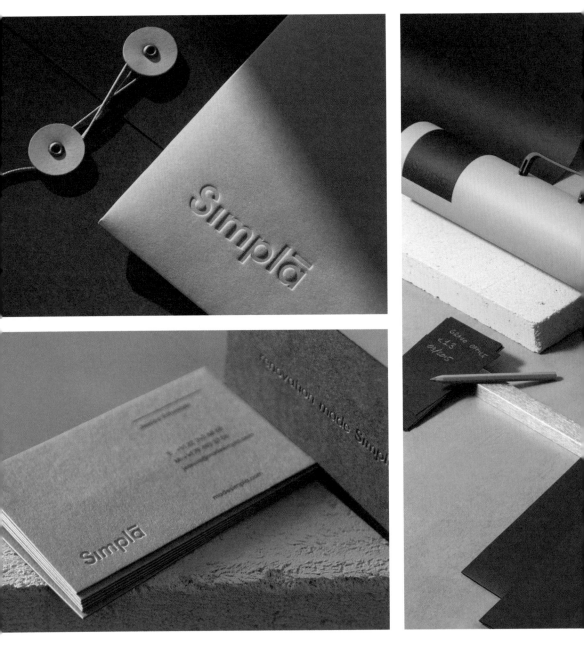

Simpla

Branding for an interior & exterior
renovation company
2016

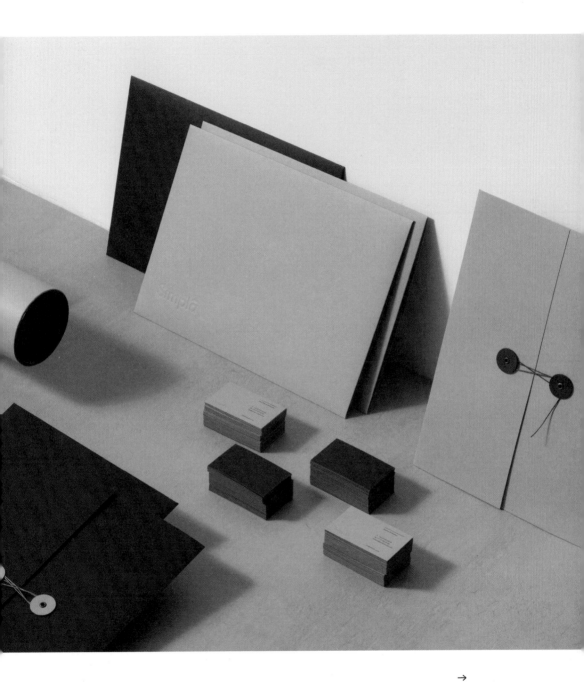

→
Heavens
Branding for a fashion label
2016

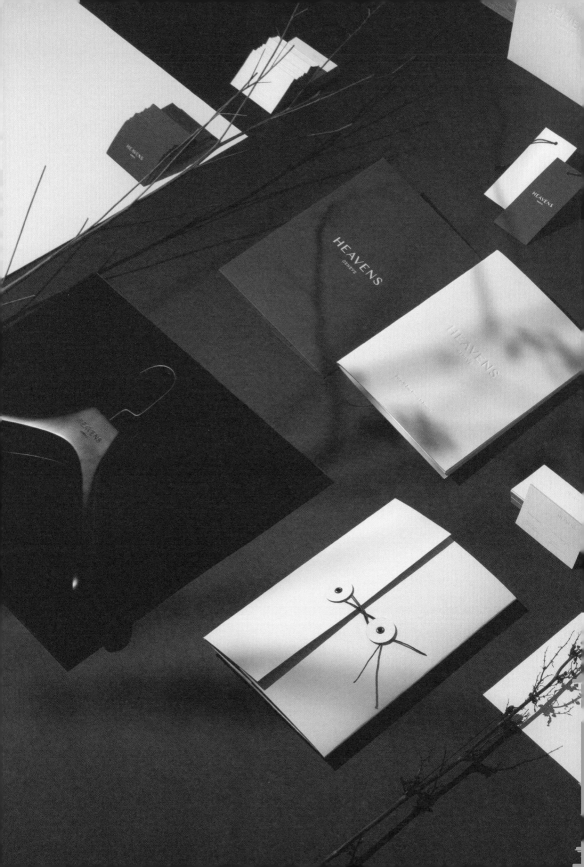

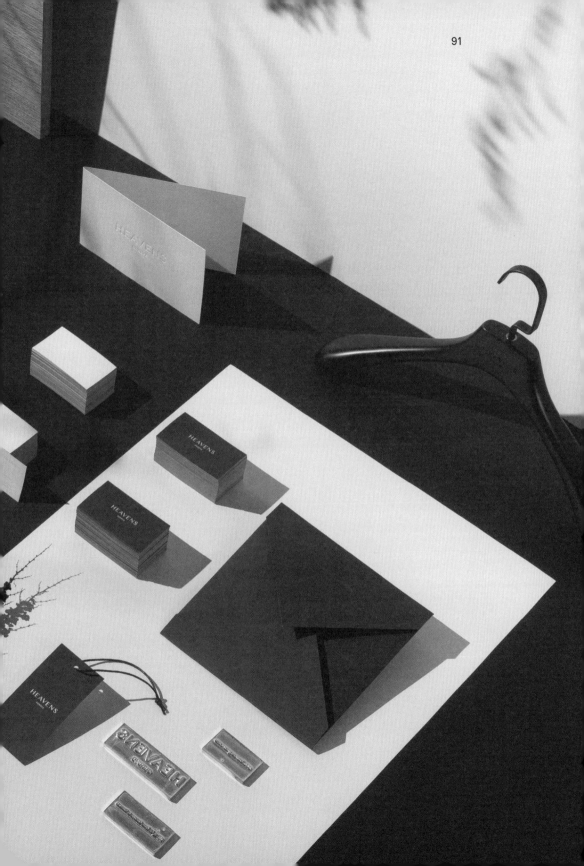

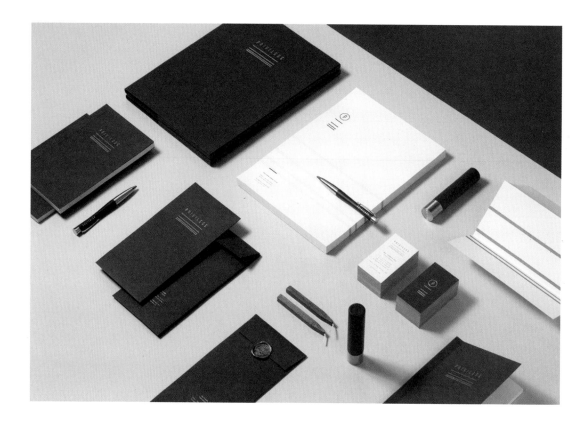

Privilege
Branding for a luxury goods dealer
2015

Réka Neszmélyi

behance.net/
rekaneszmelyi

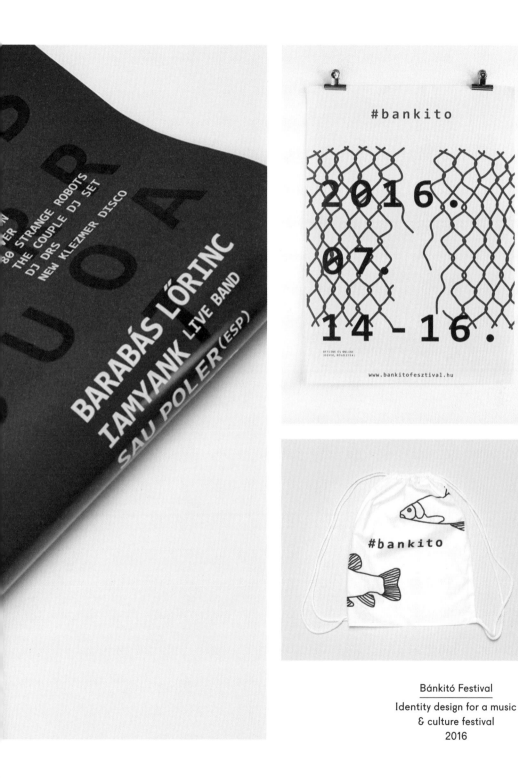

Bánkitó Festival

Identity design for a music
& culture festival
2016

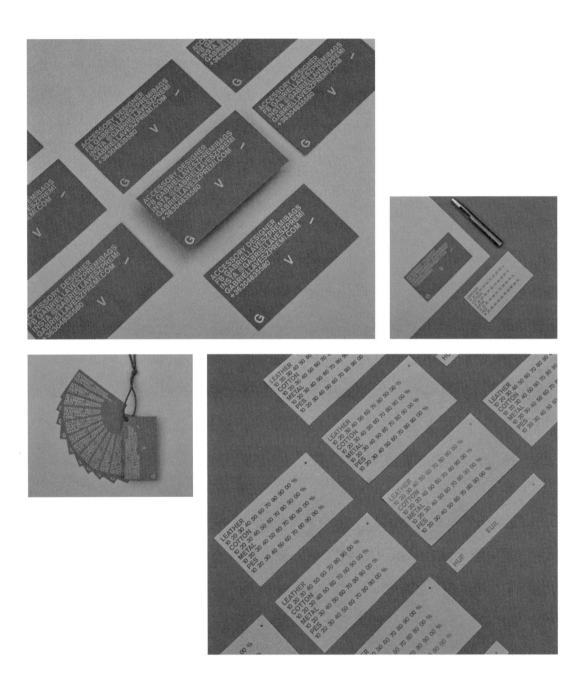

Gabriella Veszprémi
Branding for a fashion label
2017

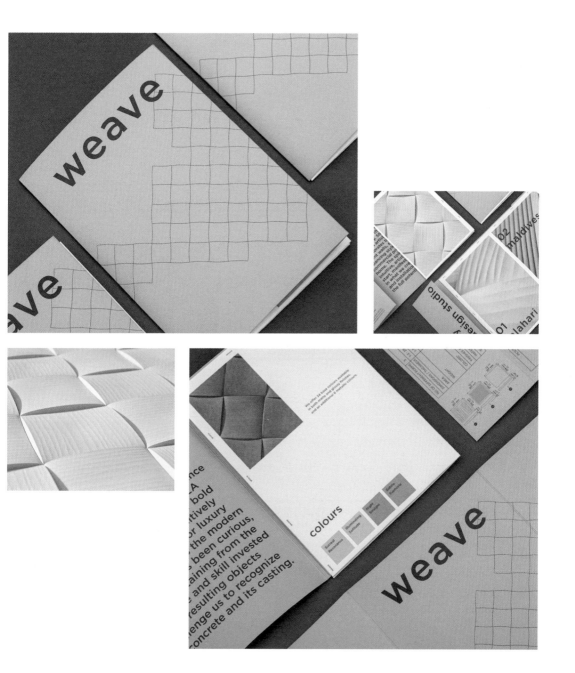

Weave

Brochure design for Kaza Concrete
2017

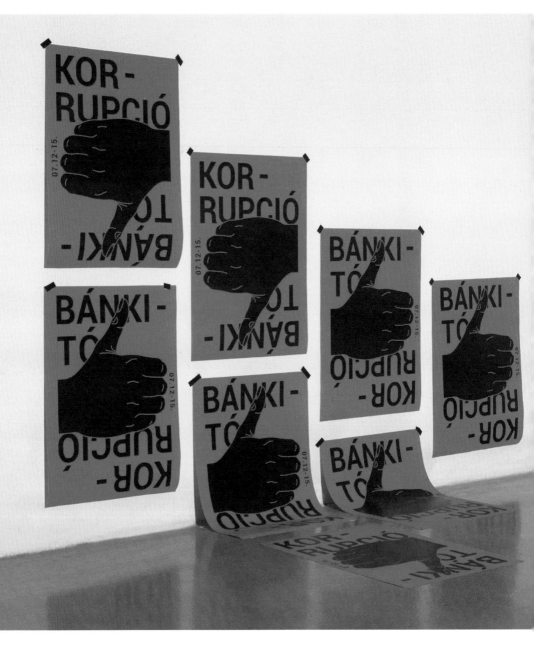

Bánkitó Festival

Identity design for a music
& culture festival
2017

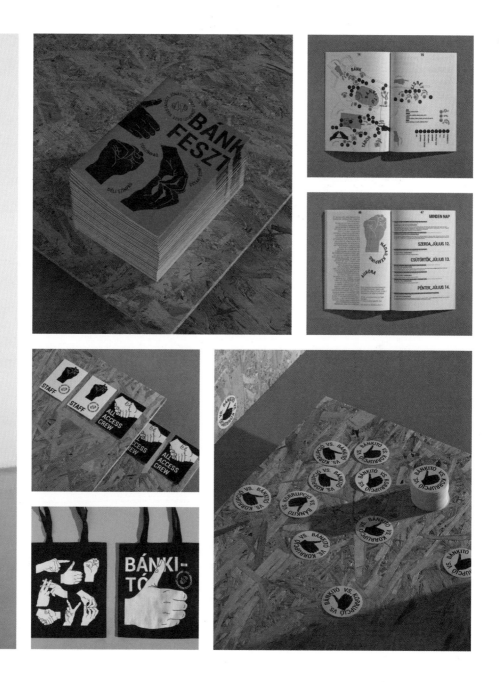

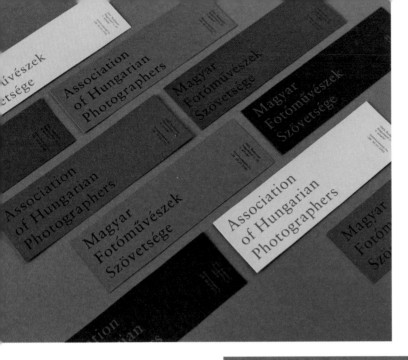

Réka Neszmélyi

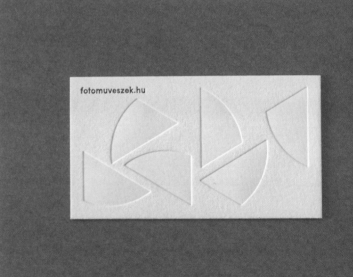

Association of Hungarian

Photographers

Branding for a photography
association
2017

240217KLUBFAMU
SATB2BJORGOS
VIKB2BO. TORR

O.TORRB2BKOSMIC SKAUTB2BSATB2BJORGOSB2BVIKB2BO.TORRB2B
KOSMIC SKAUTB2BSATB2BJORGOSB2BVIKB2B O.TORRB2BKOSMIC SK
AUTB2BSATB2BJORGOSB2B
VIKB2BKOSMIC SKAUTB2B
SATB2B JORGOSB2BVIKB2B
O.TORRB2BKOSMIC SKAUTB2BSATB2BJORGOSB2BVIK
B2BO.TORRB2BJORGOSB2BVIKB2BO.TORRB2BKOSMIC
SKAUTB2BSATB2BO. TORRB2BKOSMIC

OLIVER TORR

JORGOS

KOSMIC SKAUT

VIKB2B

SAT

GOSB2BVIKB2O.TORR
JORGOSB2BVIKB2BO.TORR

KOSMIC
SKAUTB2B
SAT

O.TORRB2BKOSMIC

SKAUT

O.TORRB2BKOSMIC
SKAUTB2BJORGOS
O.TORRB2BKOSMIC
SKAUTB2BSATB2B
JORGOSB2BVIKB2B
O.TORRB2BKOSMIC
SKAUTB2BJORGOS
B2BSATB2BKOSMIC
SKAUTB2BSATB2BJ
RGOSB2BVIKB2BSAT
O.TORRB2BKOSMIC
SKAUTB2BSATB2B
JORGOSB2BVIKB2B O.TORRB2BKOSMIC SKAUTB2BSATB2BJORGOS
B2BVIKB2B SATB2BVIK
KOSMIC SKAUTB2B
B2BO.TORRB2BSAT

Jiri Mocek

jmocek.tumblr.com

MATCH

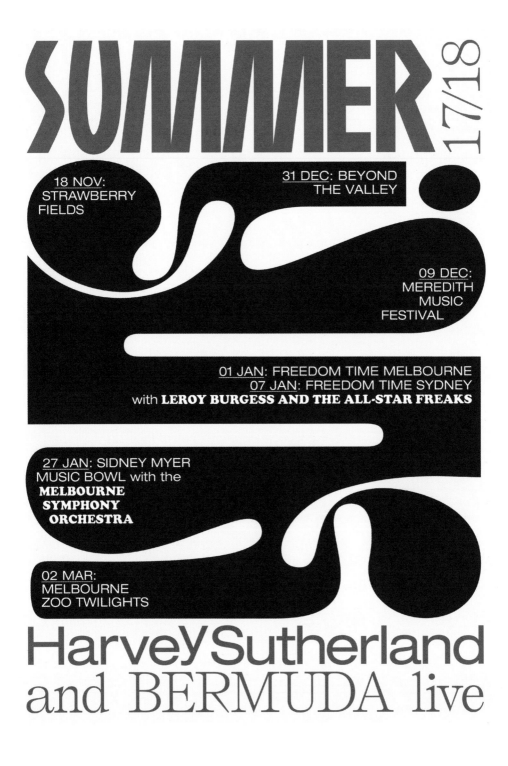

Jiri Mocek

←
Harvey Sutherland Summer Tour
Poster design for a musician
2017

Left On The Moon
Poster design for a club night
2017

Left On The Moon
Poster design for a club night
2017

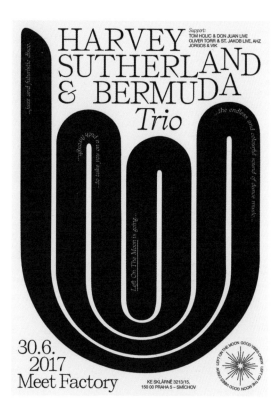

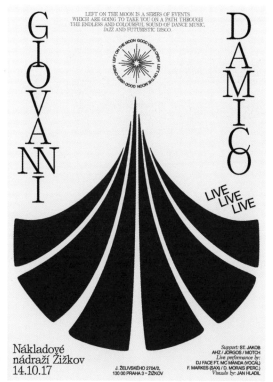

→
Zeitgeist
Poster design for a club night
2017

→
Zeitgeist
Poster design for a club night
2017

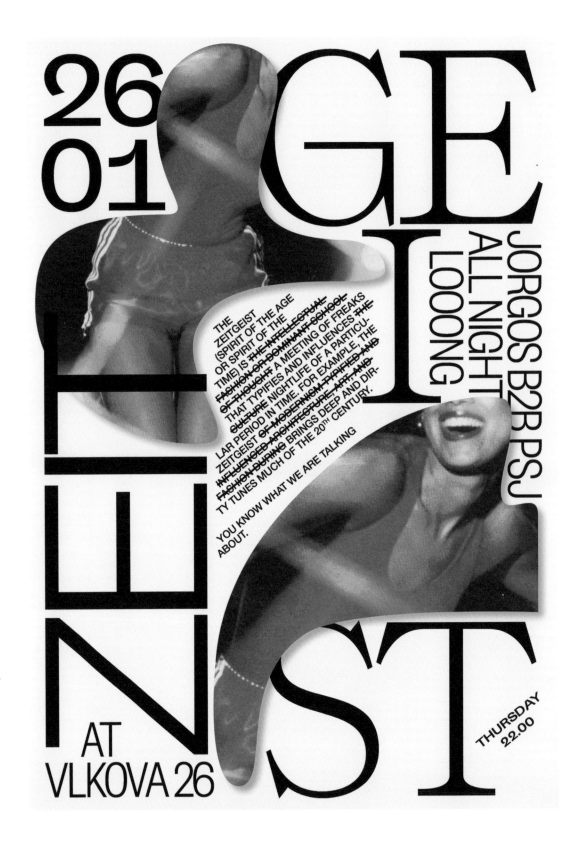

26
01

GEIST

JORGOS B2R PSJ
ALL NIGHT
LOOONG

THE
ZEITGEIST
(SPIRIT OF THE AGE
OR SPIRIT OF THE
TIME) IS ~~THE INTELLECTUAL,~~
~~FASHION OR DOMINANT SCHOOL~~
~~OF THOUGHT~~ A MEETING OF FREAKS
THAT TYPIFIES AND INFLUENCES ~~THE~~
~~CULTURE~~ NIGHTLIFE OF A PARTICU-
LAR PERIOD IN TIME. FOR EXAMPLE, THE
ZEITGEIST ~~OF MODERNISM TYPIFIED AND~~
~~INFLUENCED ARCHITECTURE, ART, AND~~
~~FASHION DURING~~ BRINGS DEEP AND DIR-
TY TUNES MUCH OF THE 20ᵀᴴ CENTURY.

YOU KNOW WHAT WE ARE TALKING
ABOUT.

AT
VLKOVA 26

THURSDAY
22.00

ZEITG

THE ZEITGEIST (SPIRIT OF THE AGE OR SPIRIT OF THE TIME) IS ~~THE INTELLECTUAL FASHION OR DOMINANT SCHOOL OF THOUGHT~~ A MEETING OF FREAKS THAT TYPIFIES AND INFLUENCES ~~THE CULTURE~~ NIGHTLIFE OF A PARTICULAR PERIOD IN TIME. FOR EXAMPLE, THE ZEITGEIST ~~OF MODERNISM TYPIFIED AND INFLUENCED ARCHITECTURE, ART, AND FASHION DURING~~ BRINGS DEEP AND DIRTY TUNES MUCH OF THE 20TH CENTURY. **YOU KNOW WHAT WE ARE TALKING ABOUT.**

W/

FATTY M & PSJ & JORGOS & VIK

22.00

IST

UVD
Poster design for an UMPRUM
lecture series
2017

Match
Poster design for a club night
2017

Nika Levitskaya
MADE

behance.net/nikalevitskaya
& made-studio.ru

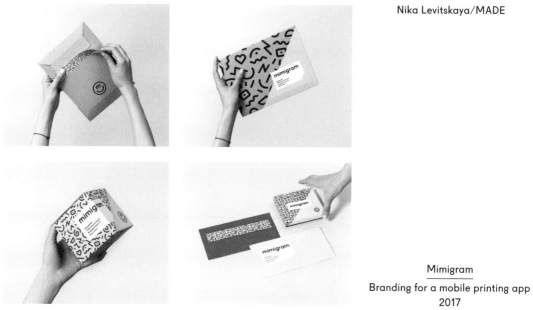

Mimigram
Branding for a mobile printing app
2017

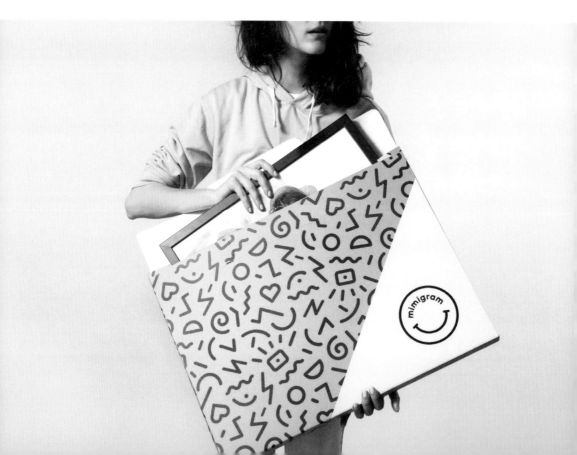

Nika Levitskaya/MADE

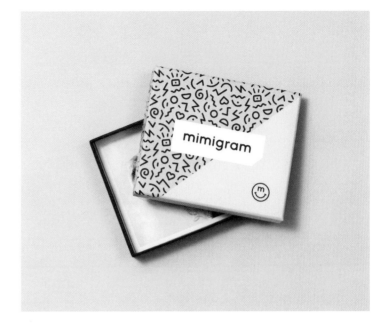

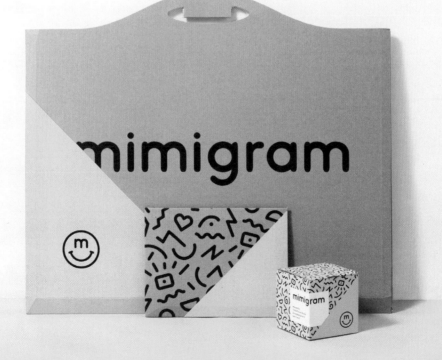

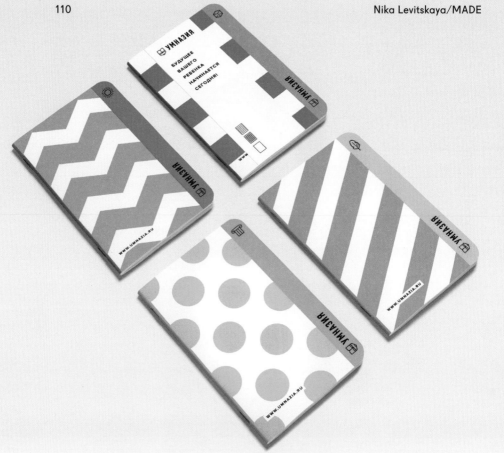

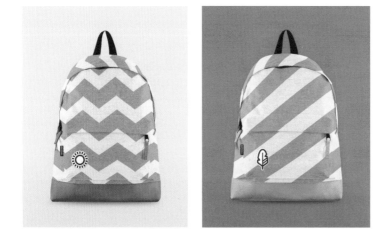

UMNAZIA.RU

Branding for Russian olympiad
games for school kids
2017

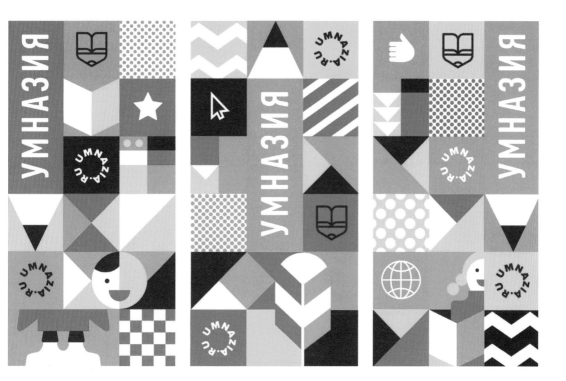

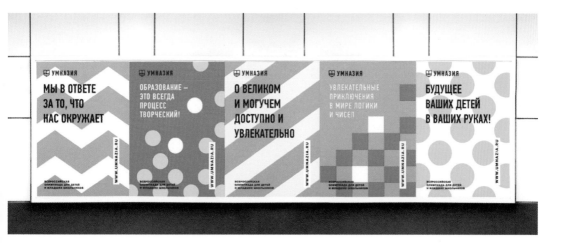

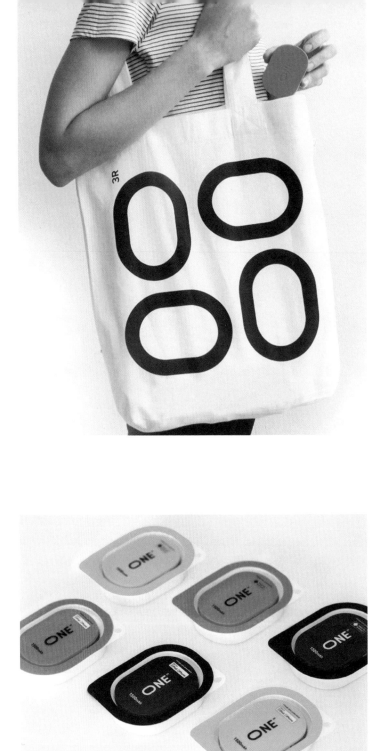

Nika Levitskaya/MADE

ONE 3R Memory

Branding & packaging design
for a phone shop
2017

Mireldy Design

mireldy.com

Split Space
Branding for a tourism company
2016

Photography
Domagoj Kunić

SMOKING SPACE

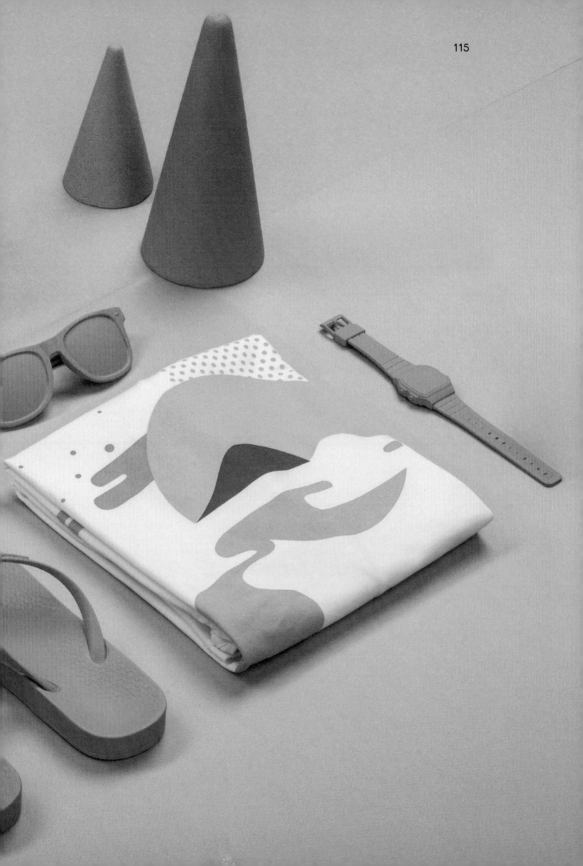

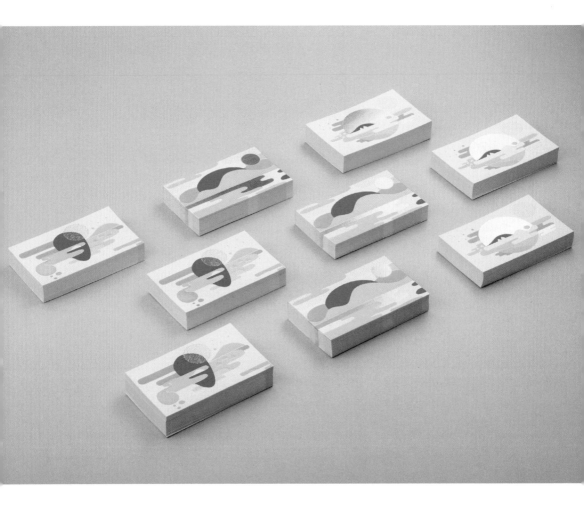

Split Space
Branding for a tourism company
2016

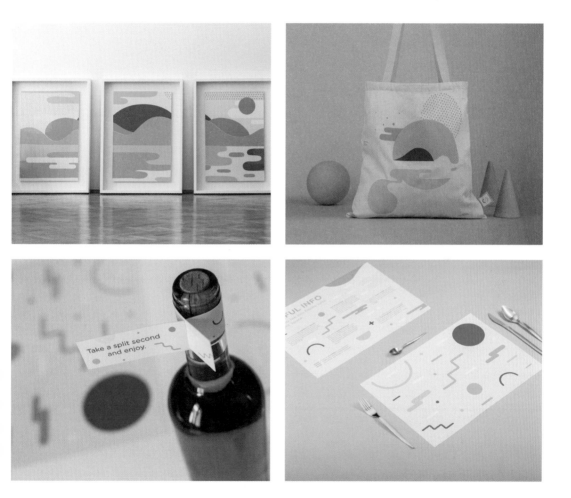

Photography
Domagoj Kunić

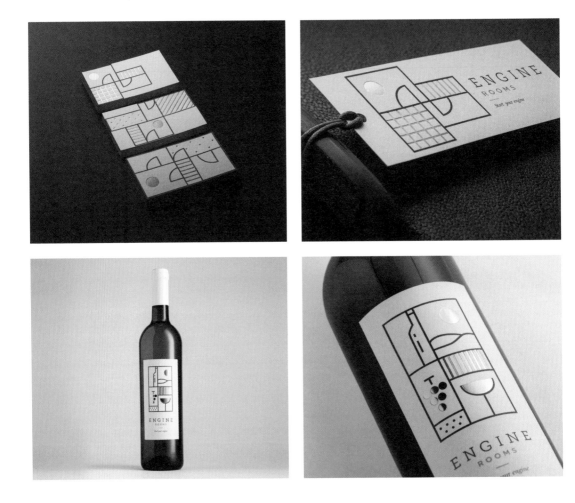

Photography
Domagoj Kunić

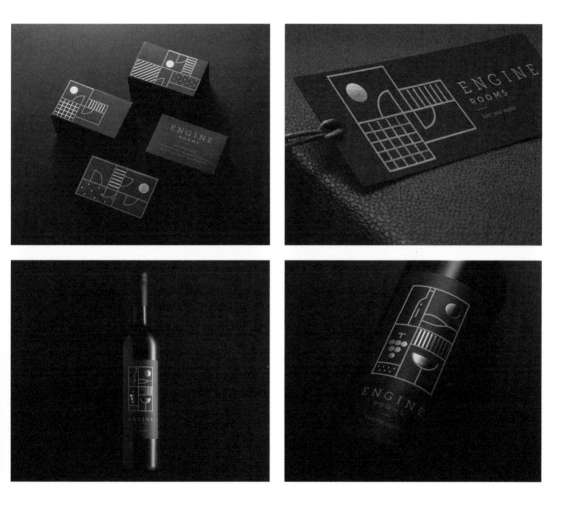

Engine Rooms
Branding for a tourism company
2018

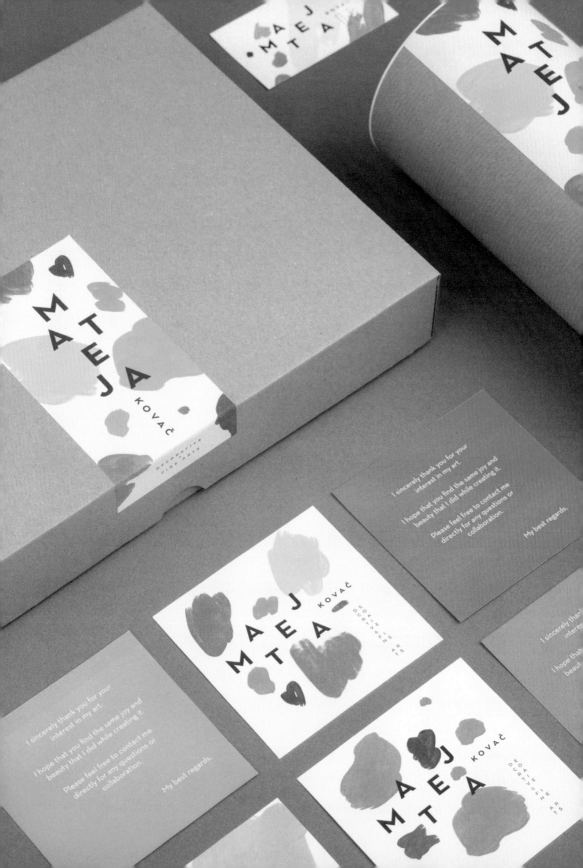

MATEJ
KOVAČ

I sincerely thank you for your
interest in my art.

I hope that you find the same joy and
beauty that I did while creating it.

Please feel free to contact me
directly for any questions or
collaboration.

My best regards,

Mireldy Design

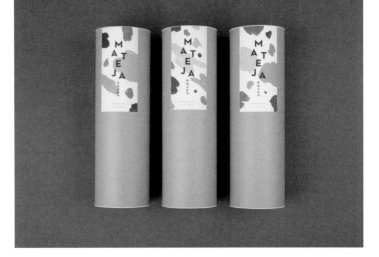

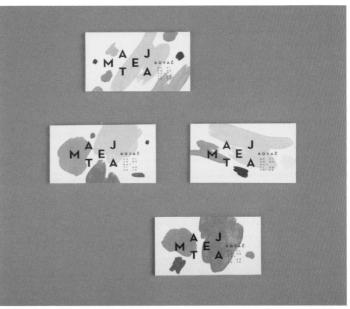

Mateja Kovač
Branding for an illustrator/artist
2017

Photography
Domagoj Kunić

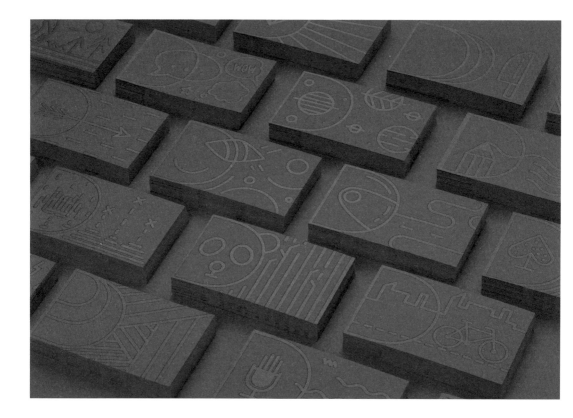

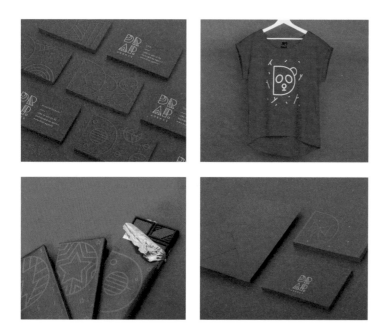

Drap
Branding for a digital agency
2017

Photography
Domagoj Kunić

Eiko Ojala

ploom.tv

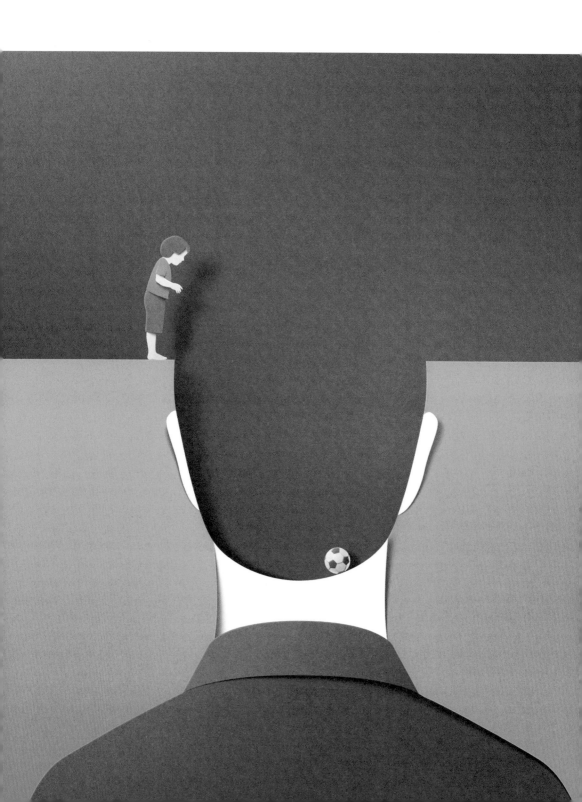

Eiko Ojala

←
Filosofie Magazine
Editorial illustration
2016 – 2018

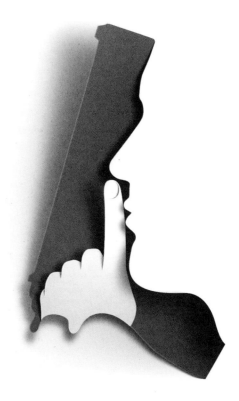

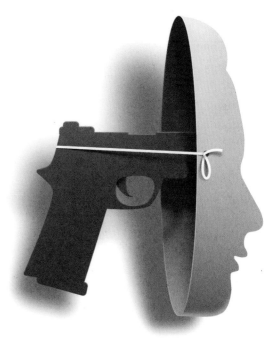

New York Times
Editorial illustrations
2016 – 2018

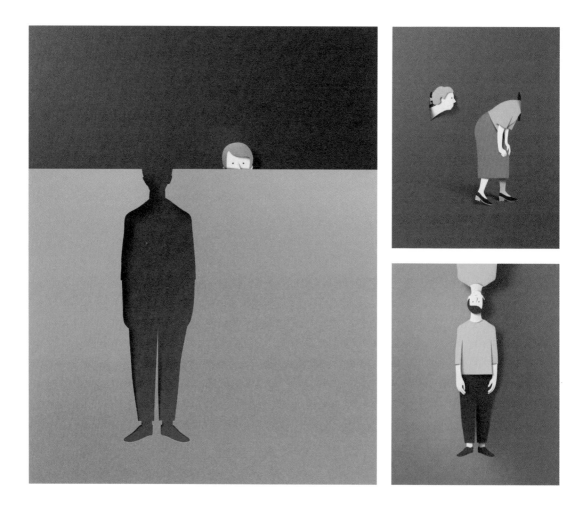

Tanz
—
Illustrations for a contemporary
dance magazine
2016

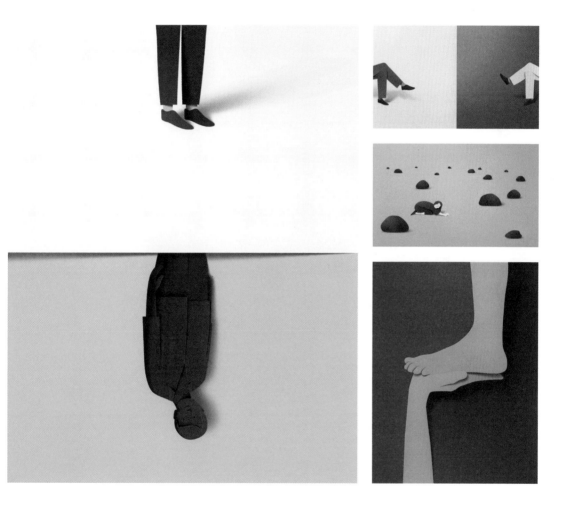

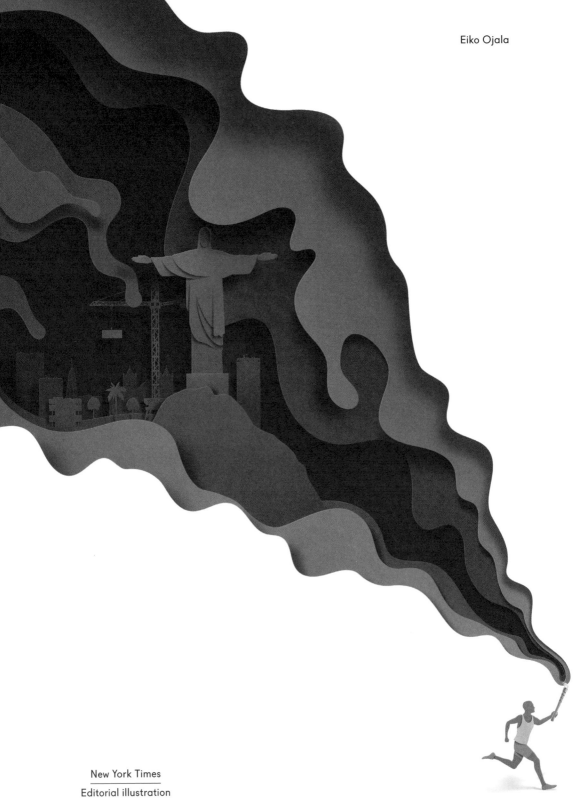

Eiko Ojala

New York Times

Editorial illustration
2016 – 2018

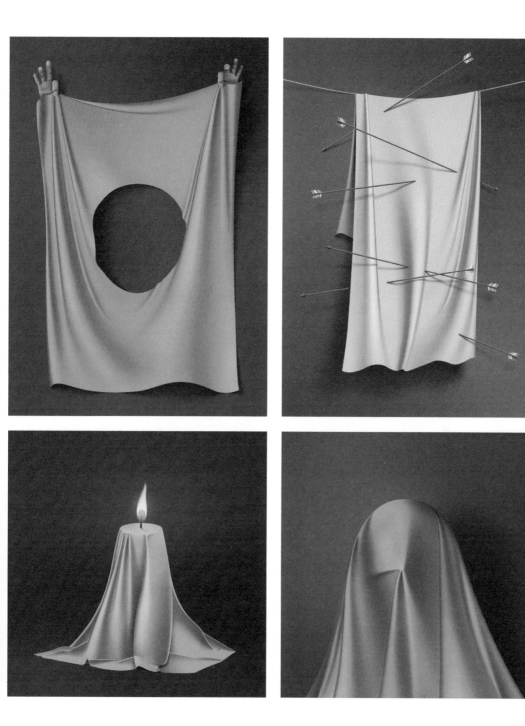

Everyday

Personal project
2015 – 2017

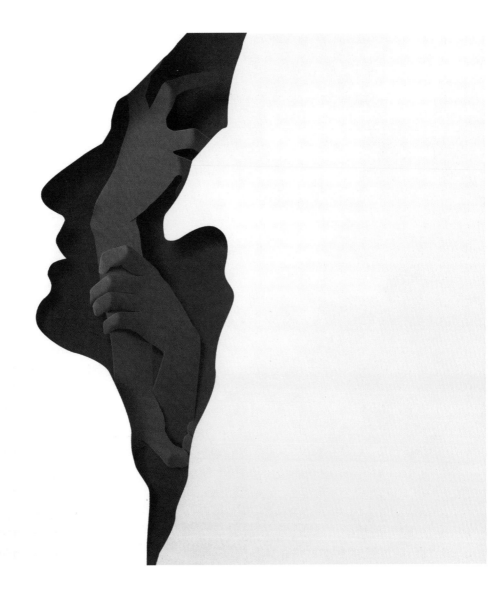

Felix Riebl
Album artwork for musician
Felix Riebl
2016

Zuzanna Rogatty

rogatty.com

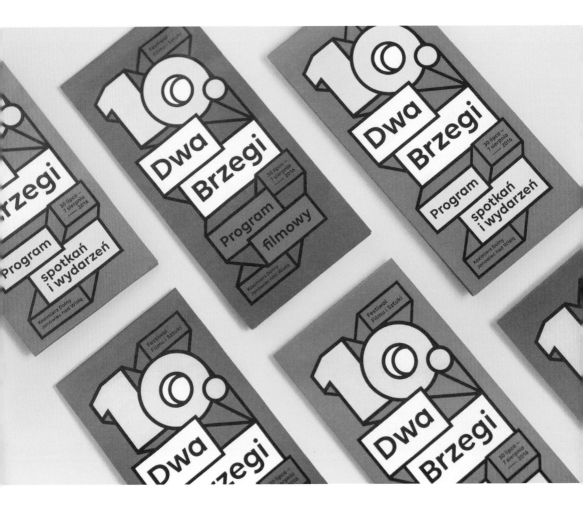

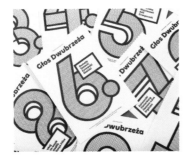

10th Dwa Brzegi Festival

Identity design for a film
& art festival
2016

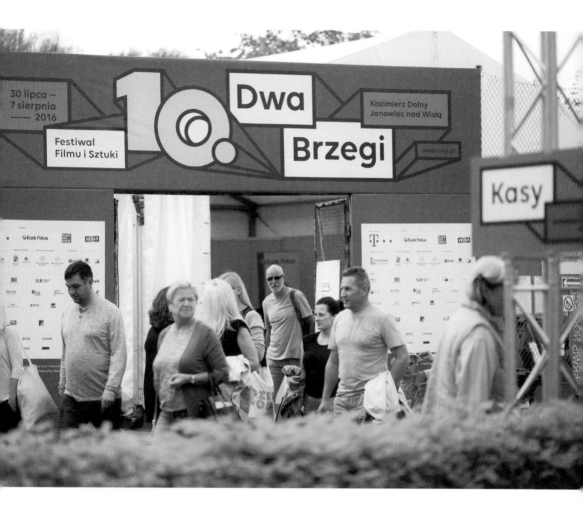

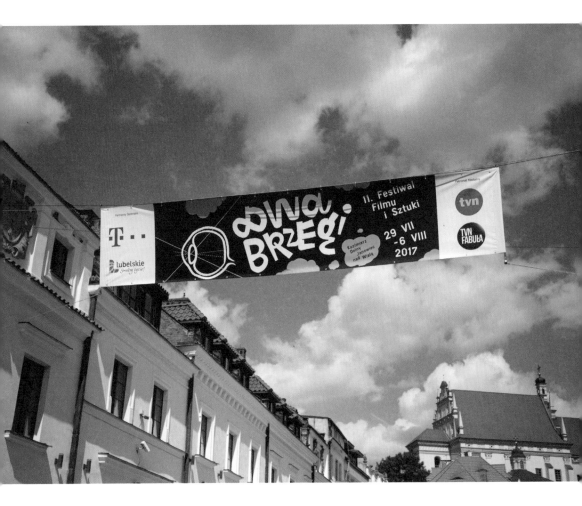

11th Dwa Brzegi Festival

Identity design for a film
& art festival
2017

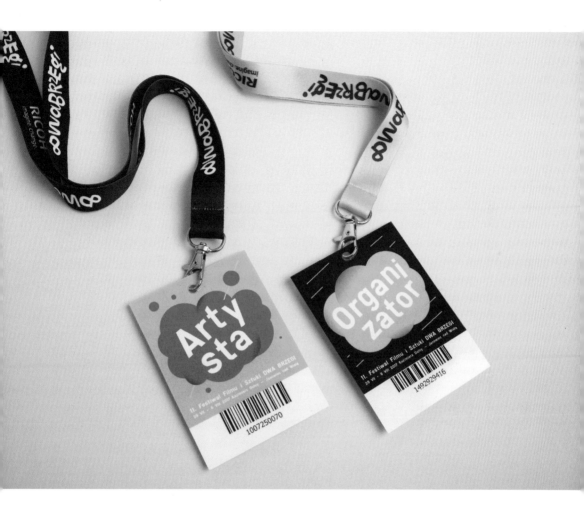

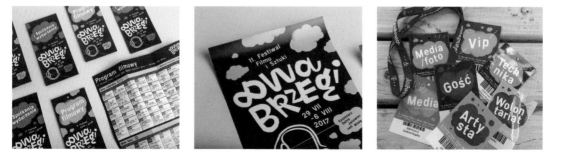

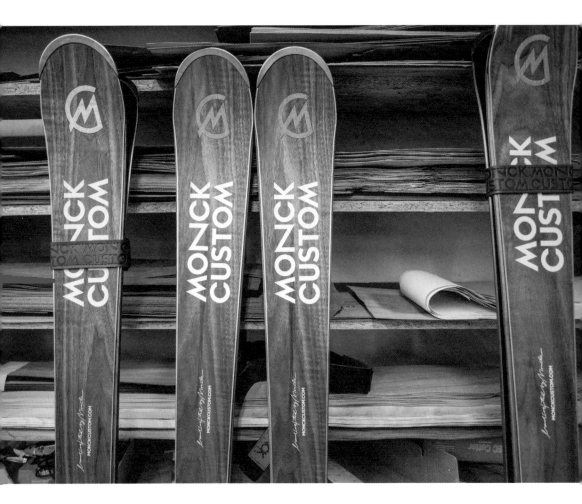

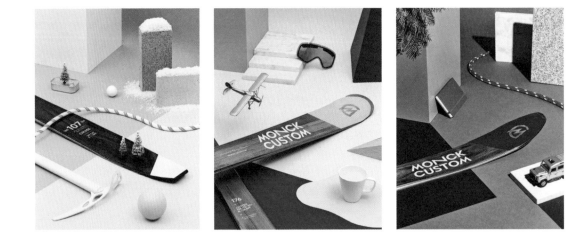

Monck Custom
————
Identity for a Ski brand
2016

Designed at Mamastudio

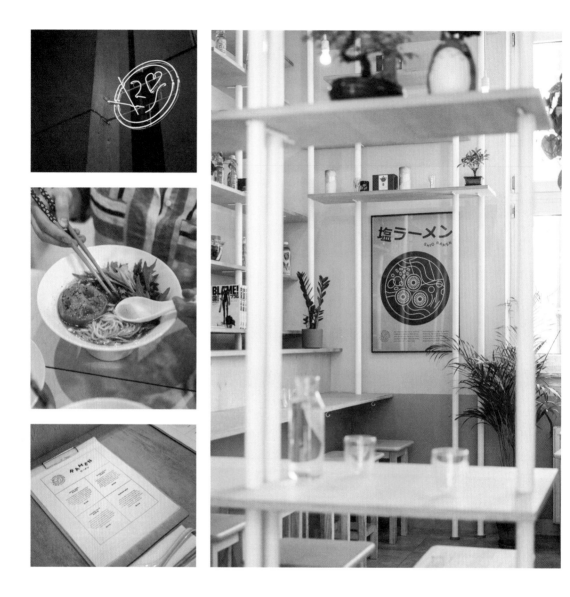

Vegan Ramen Shop

Branding for a restaurant
2016 – 2017

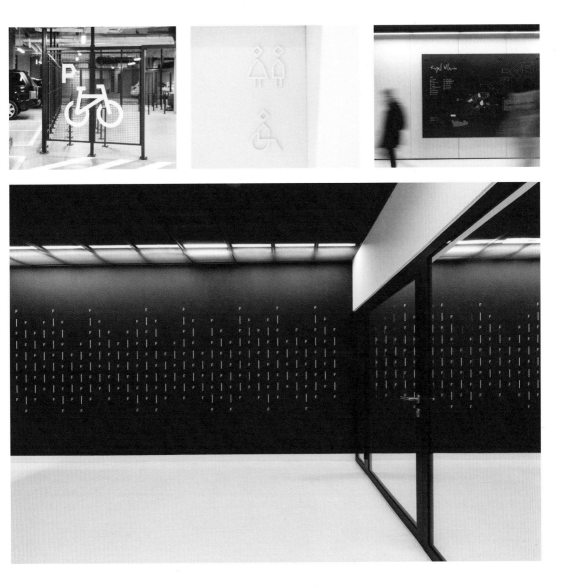

Royal Wilanów
Signage & way-finding
for an office building
2015 – 2016

Designed at Mamastudio

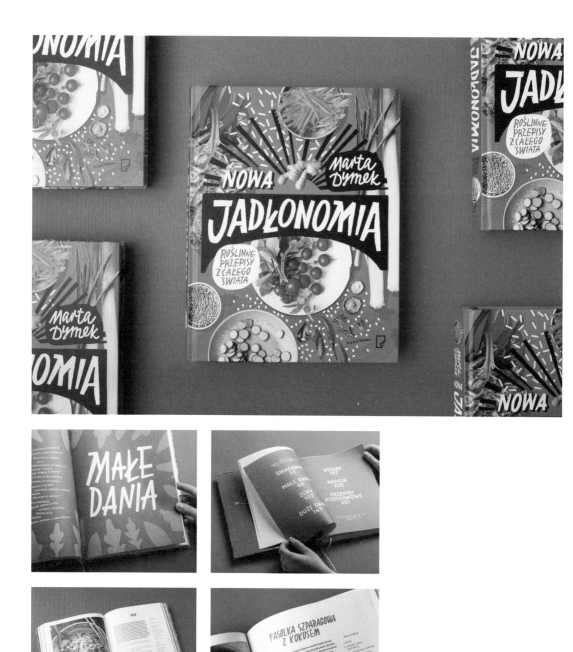

Nowa Jadłonomia

Cookbook design

2017

Słodki Komin
Branding & packaging design
for a confectionery food truck
2014

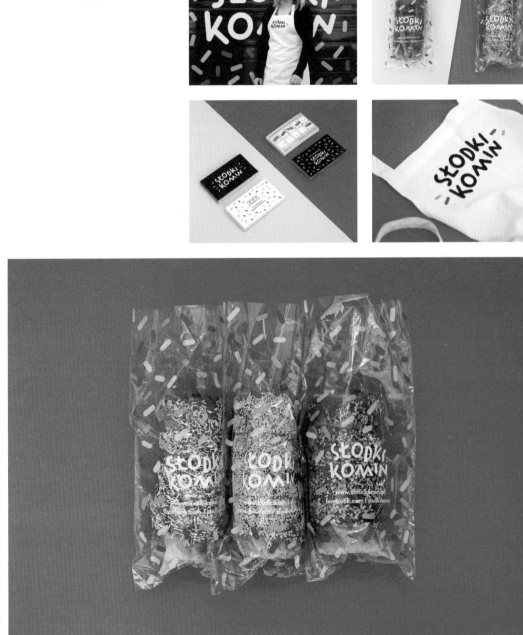

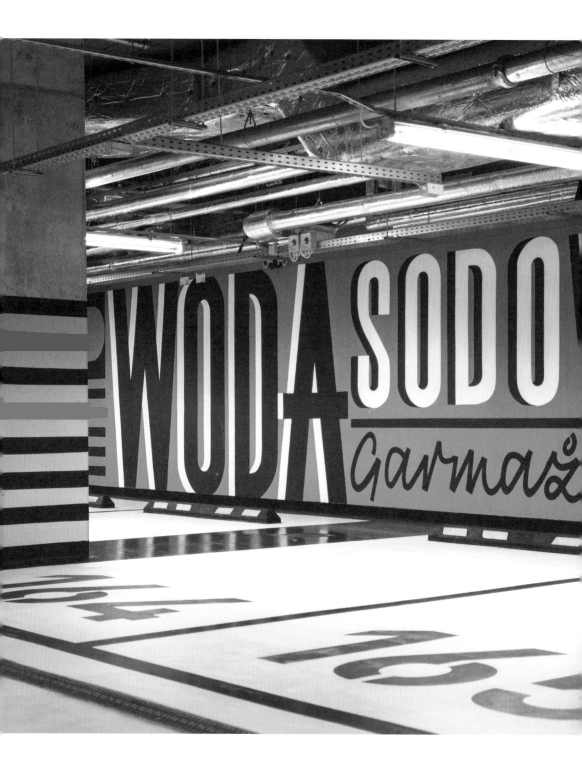

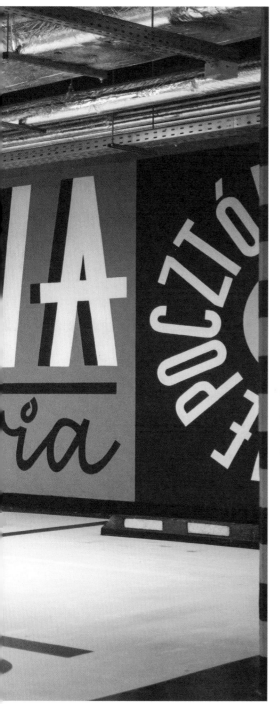

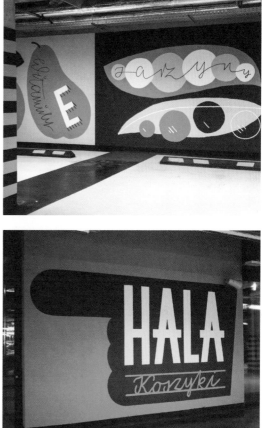

Hala Koszyki
Signage for a market hall
2016

Designed at Mamastudio

Lettering

Personal projects
2016 – 2018

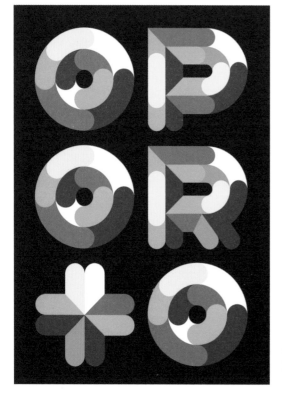

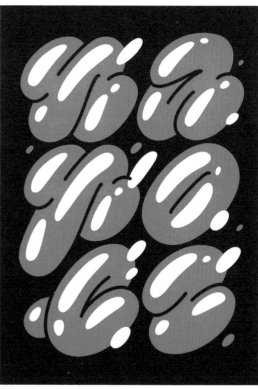

Hopa Studio

hopastudio.com

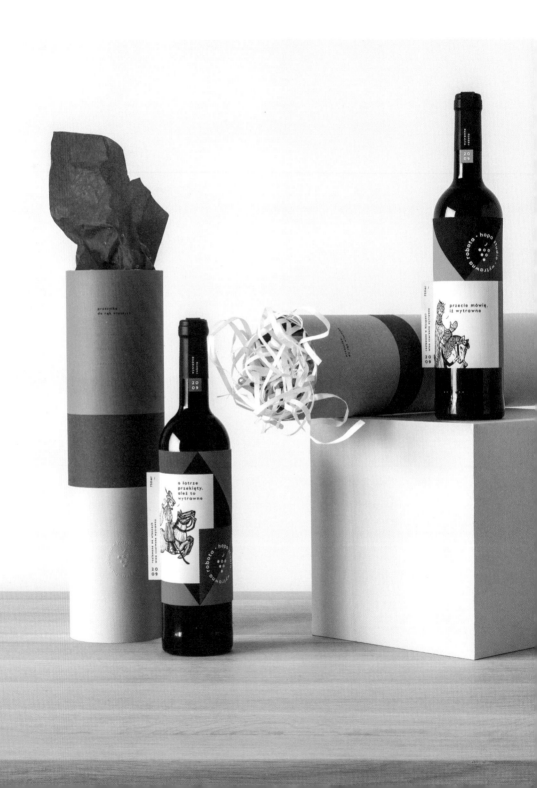

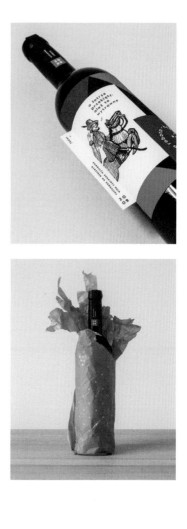

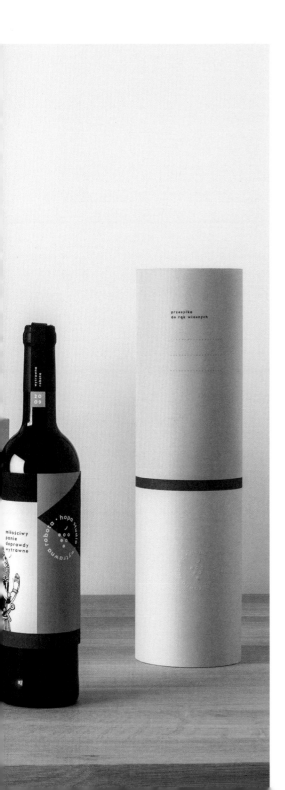

Hopa studio/Wytrawna Robota

Self-promotional packaging

2015

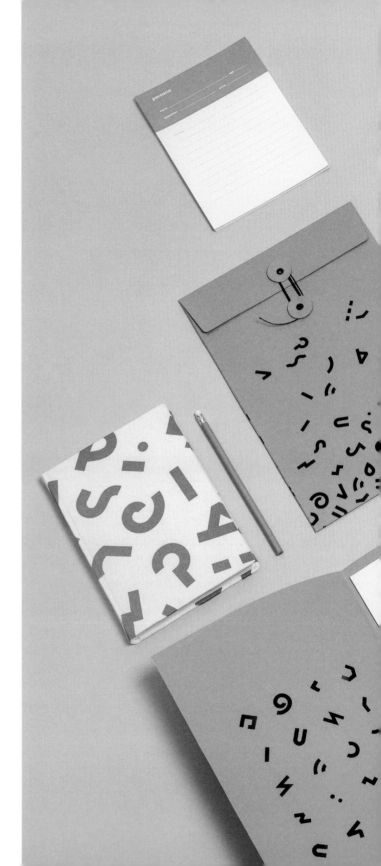

Uselab
Branding for a UX agency
2016

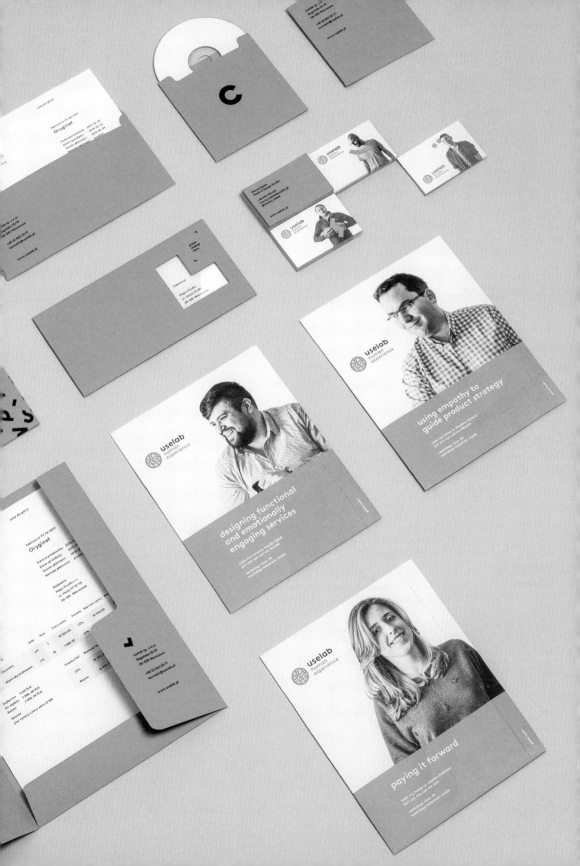

Uselab
Branding for a UX agency
2016

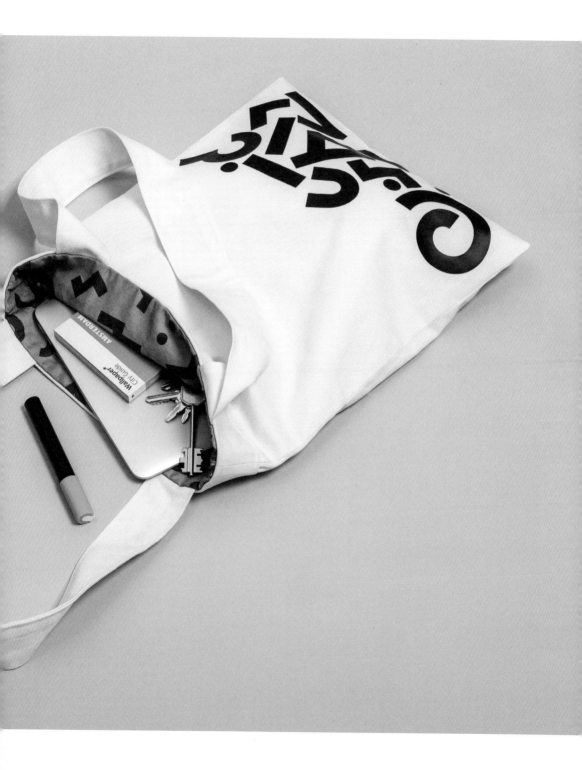

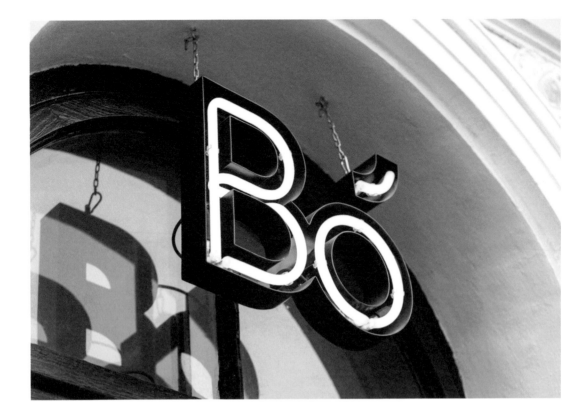

Bó
Branding for a restaurant
2016

Gawin Design

gawin.design

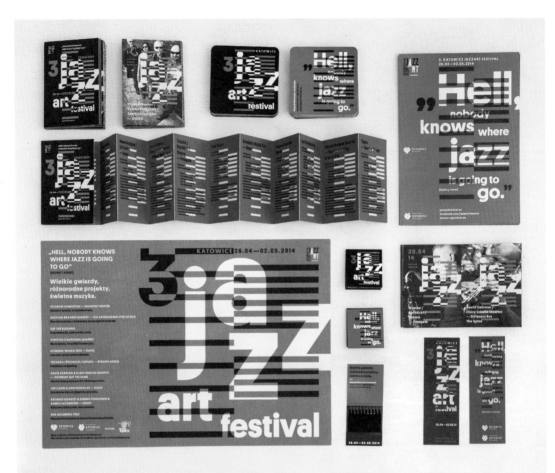

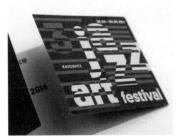

Katowice JazzArt Festival 2014

Identity for a cultural festival
2014

→

Katowice JazzArt Festival 2017

Identity for a cultural festival
2017

**6 KATOWICE
JAZZART FESTIVAL**

KRTOWICE
Miasto Ogrodów

„Jazz is not just music it's a way of life"

Marcin Krupa
Prezydent
Miasta Katowice
zaprasza

NINA
SIMONE

**21–30.04.17 KATOWICE, INTERNATIONAL JAZZ DAY
www.miasto-ogrodow.eu · www.jazzartfestival.eu**

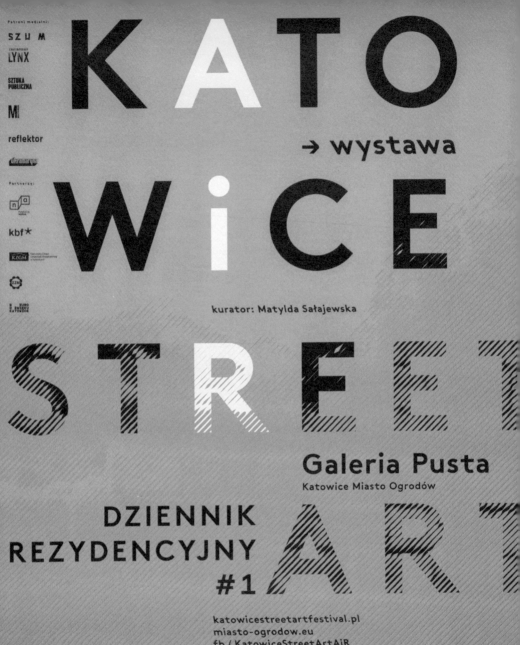

KATO

→ wystawa

WiCE

kurator: Matylda Sałajewska

STREET

Galeria Pusta
Katowice Miasto Ogrodów

DZIENNIK
REZYDENCYJNY
#1

ART

katowicestreetartfestival.pl
miasto-ogrodow.eu
fb / KatowiceStreetArtAiR

Marcin Krupa
Prezydent
Miasta Katowice
zaprasza

2017

wernisaż
14.12 do 28.01.2018
godzina
18.00

Patroni medialni:

SZUM

LYNX

SZTUKA
PUBLICZNA

MI

reflektor

Partnerzy:

kbf★

RZGM

Partnerzy:

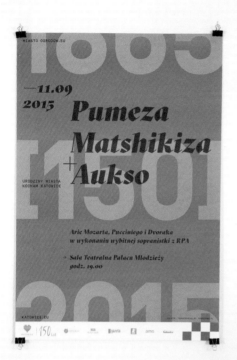

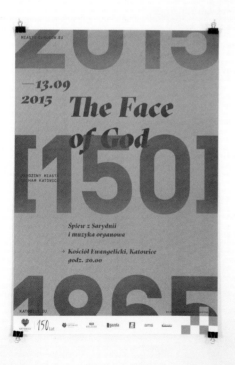

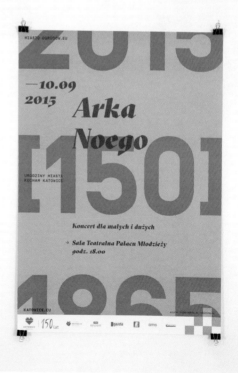

←

Katowice Street Art Festival 2017

Identity for a cultural festival
2017

Katowice City's 150th Anniversary
Celebrations 2015

Identity for a cultural celebration
2015

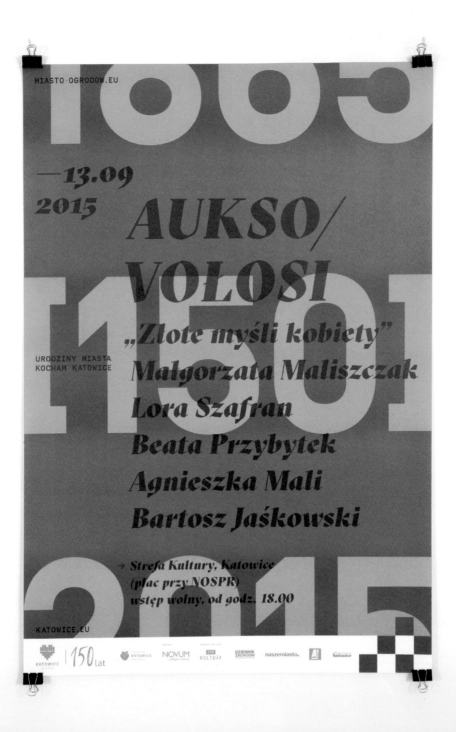

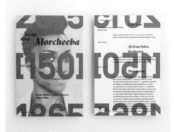

Katowice City's 150th Anniversary
Celebrations
Identity for a cultural celebration
2015

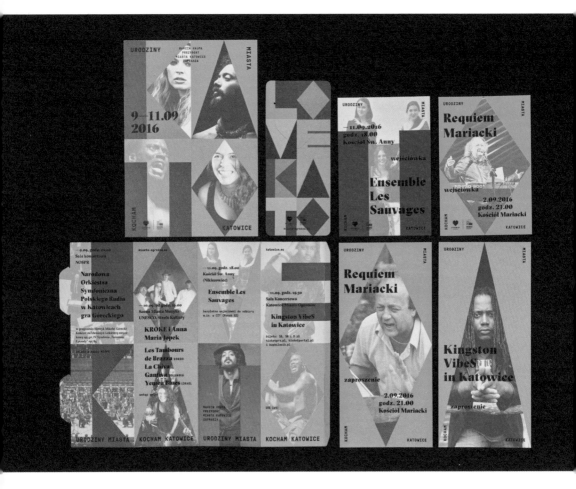

Katowice City's 151st Anniversary

Celebrations

Identity for a cultural celebration
2016

Nooeko

noeeko.com

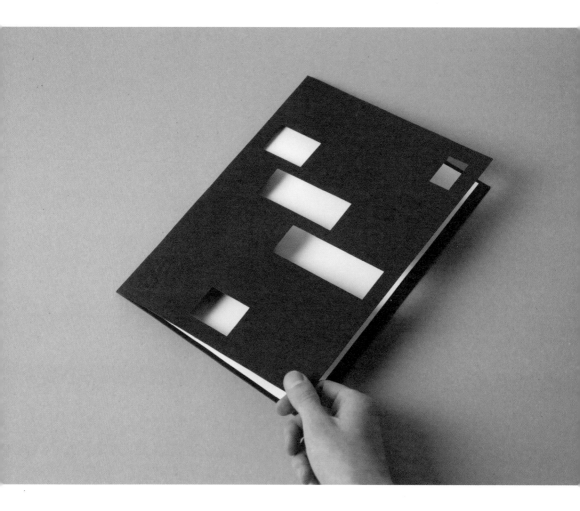

Bloc Brands

Branding for a publisher
2017

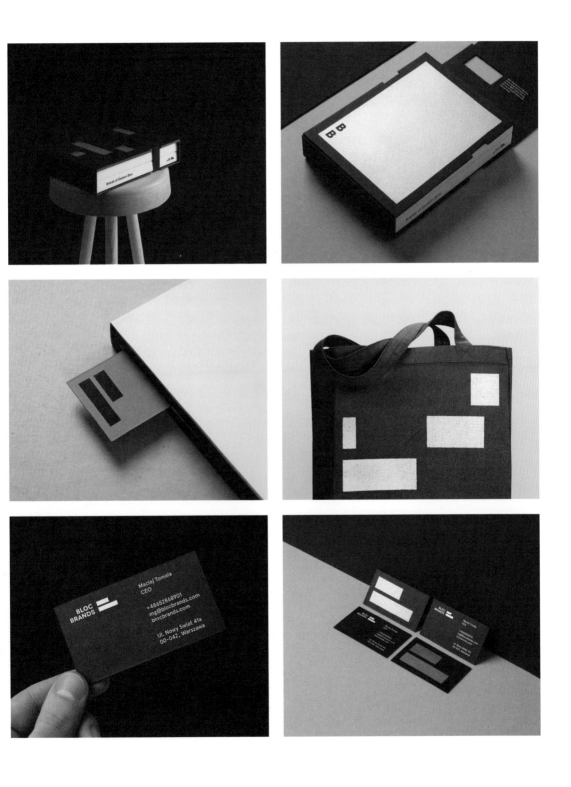

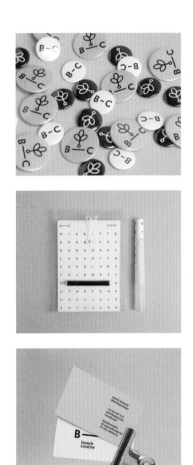

Branch Creative

Branding for an executive
production and advertising
house that represents a pool
of photographers, illustrators
& commercial directors
2014

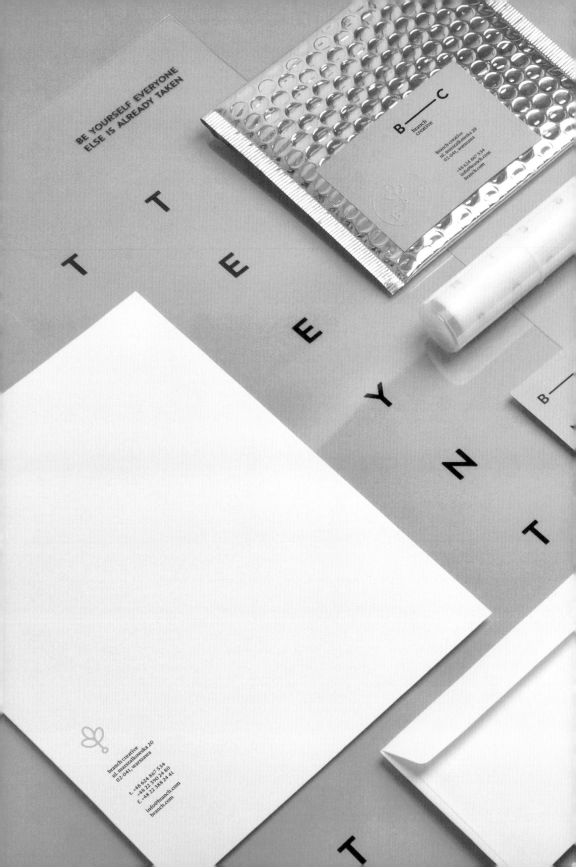

Branch Creative
Branding for an executive
production & advertising house
2014

Anna Kulachek kulachek.com
The Bakery madebythebakery.com
AKU aku.co
Metaklinika metaklinika.com
Dima Pantyushin instagram.com/d.pantyushin
Submachine submachine.co
Studio Marvil marvil.cz
Classmate studioclassmate.com
For Brands forbrands.pl
Réka Neszmélyi behance.net/rekaneszmelyi
Jiri Mocek jmocek.tumblr.com
Nika Levitskaya/MADE
behance.net/nikalevitskaya & made-studio.ru
Mireldy Design mireldy.com
Eiko Ojala ploom.tv
Zuzanna Rogatty rogatty.com
Hopa Studio hopastudio.com
Gawin Design gawin.design
Nooeko noeeko.com